THE ENTHUSIAST'S GUIDE TO MULTI-SHOT TECHNIQUES

49 Photographic Principles You Need to Know

ALAN HESS

THE ENTHUSIAST'S GUIDE TO MULTI-SHOT TECHNIQUES:
49 PHOTOGRAPHIC PRINCIPLES YOU NEED TO KNOW

Alan Hess

Project editor: Jocelyn Howell
Project manager: Lisa Brazieal
Marketing manager: Jessica Tiernan
Layout and type: WolfsonDesign
Design system and front cover design: Area of Practice
Front cover image: Alan Hess

ISBN: 978-1-68198-134-5
1st Edition (1st printing, October 2016)
© 2016 Alan Hess
All images © Alan Hess unless otherwise noted

Rocky Nook Inc.
1010 B Street, Suite 350
San Rafael, CA 94901
USA

www.rockynook.com

Distributed in the U.S. by Ingram Publisher Services
Distributed in the UK and Europe by Publishers Group UK

Library of Congress Control Number: 2016930702

This book is printed on acid-free paper.
Printed in China

Dedicated to Nadra Farina-Hess

ACKNOWLEDGMENTS

BEING A WRITER can be a lonely job, with late hours spent hunched over a keyboard trying to get the information to sound just right. It's a good thing I have such a great team that takes those words (and images) and creates something special with them. I want to thank all of the people who hand a hand in getting this book into your hands, because without them, this would not have been possible. A huge thank you to Scott Cowlin, Ted Waitt, Jocelyn Howell, Jessica Tiernan, Lisa Brazieal, and the whole Rocky Nook family.

Thank you to my family and friends for putting up with me during the writing process. I know I keep saying it will get easier and I'll work normal hours, but by now you must know that is just not going to happen.

There are a few friends out there who understand what it is like to write a book while still trying to stay reasonably sane. These individuals make doing this easier because they understand the inevitable moments of self doubt and they are there to talk you off the ledge. Two of the best are Glyn Dewis and Dave Clayton, both of whom I owe a piece of my sanity—they can make me laugh when I need it the most.

Finally, I need to thank my wife, Nadra, for putting up with yet another book and the crazy ups and downs that go along with being a photographer and writer. Nadra is calm, cool, and collected, which makes all this possible.

CONTENTS

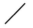

CONTENTS

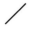

1

DOUBLE
EXPOSURE

CHAPTER 1

Double exposure is a photographic technique where you combine two images to create a single image. This technique usually involves just two images, hence the term double exposure, but many digital cameras allow you to blend three or more images into a "multiple" exposure. For the sake of simplicity, I am going to use the term double exposure throughout this chapter, even though you could combine more than two individual frames.

When using a film camera to create a double exposure, you take two photos on the same piece of film to create a single unique image. With digital technology it is possible to create the same effect with two different images by blending them together in-camera or in post-production with photo-editing software like Adobe Photoshop.

In this chapter I begin by explaining how to create double exposures in the camera, and then I move on to describing how to combine images in post-production using Adobe Photoshop. One of my favorite techniques for creating double exposures is using a flash to illuminate the same subject more than once in the same frame. It's easy and lots of fun to play with. This chapter also covers double exposure techniques for action photos and portraits.

1. DOUBLE EXPOSURE BASICS

WHEN USING FILM to create double exposures, you take the first shot, and then without winding the film forward you take a second shot, exposing the same frame of film to more light and creating two exposures in the same image. When I was first learning the art of photography, I did this on a regular basis, many times by mistake. The first cameras I used were manually operated and you had to remember to wind the film forward after each shot; sometimes I just forgot. After I shot an entire roll, I would to go into the darkroom and develop the film to see what I had captured, and sometimes I'd be surprised by a double exposure when I really wasn't expecting it. As cameras got smarter, or at least more advanced, I had to purposely rewind the film back a frame to shoot a double exposure. I still took quite a few double exposures because it was a quick and easy way to create a new and unique image.

When you shoot a double exposure with a film camera, the two exposures are overlaid, one on top of the other, and they are added together. This means the amount of light reaching the film increases when you take the second image. If you shoot the exact same image with the same exposure settings twice and overlay the two exposures, the resulting shot will be a full stop lighter because you are doubling the amount of light that reaches the film or sensor. **Figure 1.1** shows a single exposure of a flower. I then shot the image again to create an in-camera double exposure, which you can see in **Figure 1.2**. Notice that the second image is one stop brighter.

You can control how much of the second image is seen by working with the light and dark areas of the first image. In the lighter areas of the first image, less of the second image will be seen, while in the darker areas of the first image, more of the second image will be seen.

If the first image has any areas that are pure white, it means that these areas were exposed to so much light that they won't be able to react when they are exposed to more light during the second exposure. The second exposure will not be visible in these areas. The areas in the first exposure that are dark can still be exposed to light, and these areas will show more of the second exposure. In the image of my dog Maggie on page 18, the first frame (the dog) had a pure white background, which meant none of the second frame (the tree against the sky) can be seen outside of Maggie's profile in the combined image. This type of image can easily be created in Photoshop or another image-editing software, but there is something really fun about creating the image in-camera.

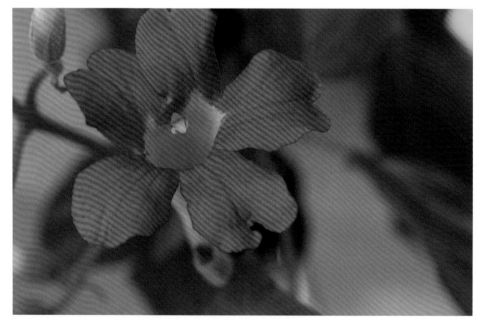

1.1 A single-frame exposure of a flower.

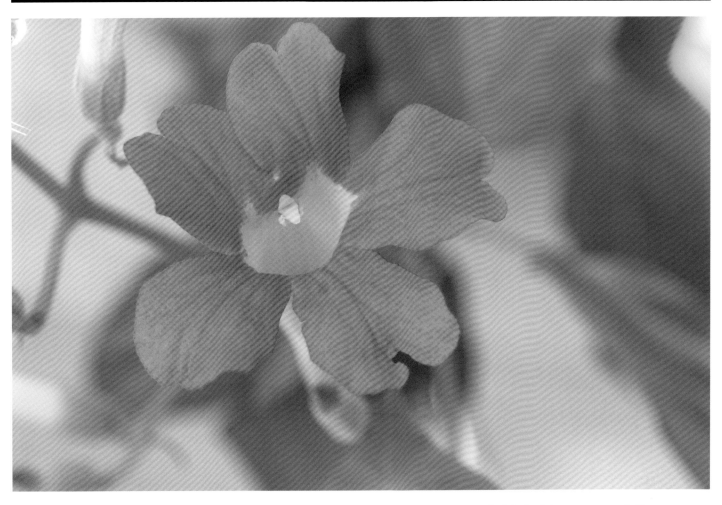

1.2 A double exposure of the same flower that is shown in Figure 1.1. This image is a full stop lighter.

2. CREATING IN-CAMERA DOUBLE EXPOSURES WITH A DIGITAL CAMERA

NOT ALL DIGITAL cameras allow you to create double exposures in-camera, so before trying these techniques out, check the user's manual for your camera to see if this is possible. If your camera doesn't allow for in-camera double exposures and you really want to try this method out, I suggest borrowing a camera from a friend or renting one from an online camera rental service or your local camera store. Keep in mind that even if you can't create double exposures in-camera, you can still use some of the other techniques discussed in this chapter, so I suggest reading this section anyway to get an idea of how the double exposure technique works. The same basic ideas can be used in the next section, but instead of combining the shots in-camera, you will combine them on the computer using image-editing software.

Before you create a double exposure in the camera, you need to know what two scenes you want to combine. Ideally your subjects should be close to one another because you won't have a lot of time between the two exposures. There are a couple of reasons for this. The first is that many cameras turn off automatically after a set amount of time has passed, and if the camera turns off and then back on in between the exposures, it can cancel out the double exposure setting. The second reason is that you usually can't preview the first image before you take the second one, so you need to have a clear memory of the first image to compose the second one properly.

Some cameras have a multiple exposure mode that allows you to combine two (or more) successive images into a single file. When you use this mode, you shoot two (or more) images and the camera automatically combines them and saves them as one file. This is the technique that is covered here. Other cameras allow you to combine any two photos on the memory card in the camera, but this is much more like creating a double exposure in post-production than in-camera.

Creating an in-camera double exposure with a digital camera is very similar to creating one with film, but instead of recording the information on the same piece of film, the camera stores the first frame on the memory card and then blends the photo information from the second frame with that of the first. Each camera does this in a slightly different way, so it pays to experiment with your camera and figure out which settings you need to adjust in the multiple exposure mode. For example, on my Nikon D750 I can pick how many images I want to blend together—either two or three—and decide whether the camera should apply auto gain to the images or not. Auto gain attempts to automatically adjust the exposure for each frame so that the final combined image is properly exposed. I usually use two exposures and turn the auto gain on because this gives me the best results in most situations (**Figure 2.1**). If you're shooting two frames with dark backgrounds, try turning the auto gain off.

Once you've selected the multiple exposure mode in your camera and adjusted the appropriate settings, you need to take the two photos. While this isn't difficult to do, sometimes it can be challenging to get the results you want. It's best to have an idea in mind before taking the images so that they can work together to create the double exposure. As I mentioned previously, I like to photograph two things that are close together. For example, in **Figure 2.2** I combined a portrait of my wife, Nadra, in the yard with a shot of the surrounding trees. First I photographed Nadra against the sky, overexposing the photo so that the background was pure white. Then I changed the exposure and photographed the tree and sky to create the double exposure.

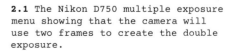

2.1 The Nikon D750 multiple exposure menu showing that the camera will use two frames to create the double exposure.

2.2 An in-camera double exposure created by photographing the subject against the sky and then photographing a nearby tree and blending the two exposures together.

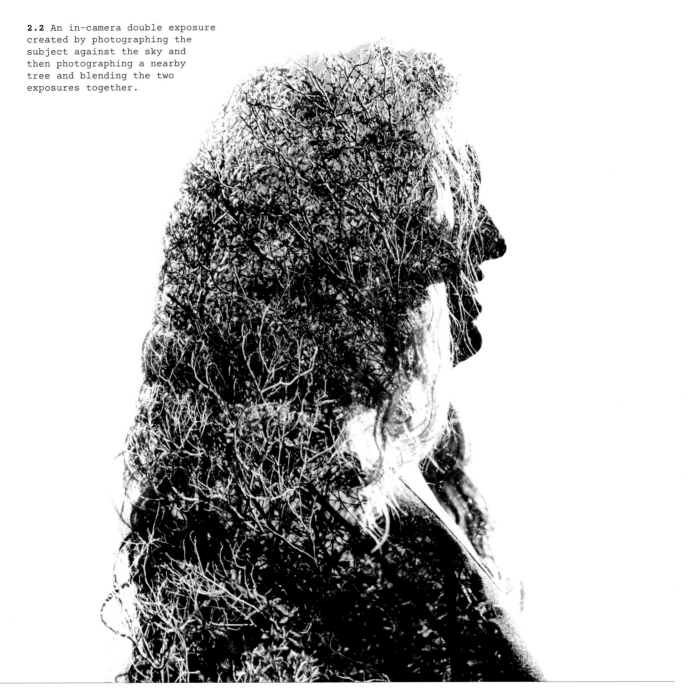

When you first start to experiment with double exposures, it's a great idea to photograph one subject and then just add texture from another. For example, to create the image shown in **Figure 2.3** I combined a photograph of my dog against the sky with a wooden tiki head we have in our yard. When the images are blended together, you can see the outline of the dog and the texture of the tiki head. The silhouette of the dog and the placement of the eyes from the tiki created a really interesting image. You can see the tiki head in **Figure 2.4**.

I created each double exposure I've shared so far by shooting the first exposure in a very bright area so that the second image is visible only in the darker areas of the first image. You can also create great double exposures by using images with dark areas, as seen in **Figure 2.5**.

The downside of creating a double exposure in the camera is that you have very little control over the final image. The two images are combined in the camera and cannot be separated.

2.3 Is it a dog or a tiki head, or both?

2.4 The tiki head without the dog outline isn't nearly as interesting as the double exposure.

2.5 The base image is a photo of a liquor sign and the second exposure is of liquor bottles. You can actually see the bottles twice in the image: overlaid on the liquor sign and at the bottom center of the image.

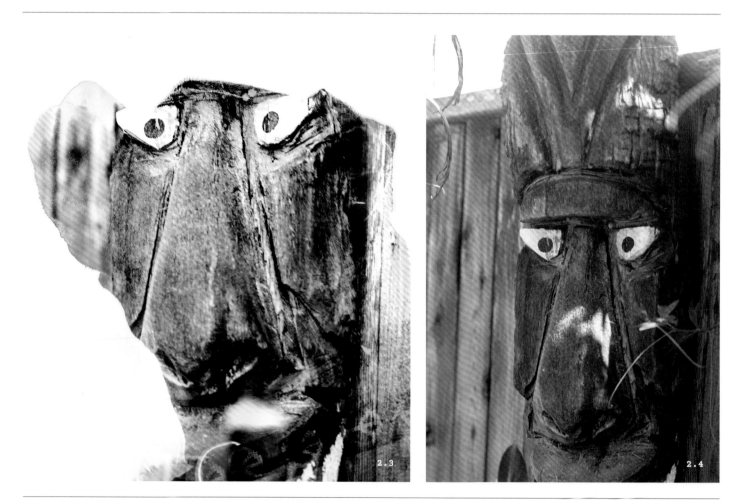

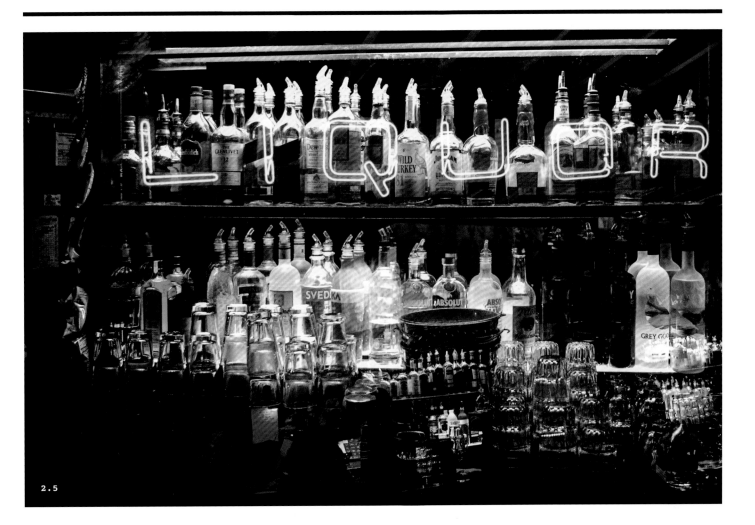

2.5

3. CREATING DOUBLE EXPOSURES IN POST-PRODUCTION WITH ADOBE PHOTOSHOP

THIS IS NOT an Adobe Photoshop book, but Photoshop is one of the best image-editing programs available and is great for creating double exposures in post-production. In this section I explain how to use Photoshop layers and the layer blend modes to create something close to the effects you can get when shooting double exposures in-camera. Another benefit of Photoshop is it allows you to fine tune the placement and opacity of your two images.

I am going to keep this as basic as possible, so just follow these steps to get started:

1 **Open the images:** Open the two photographs you'd like to combine in Photoshop and edit them so that each photo looks the way you want it to.

2 **Combine the images:** Decide which of the two images will be the base layer and which will overlay the base image. Drag the second image over the first (**Figure 3.2**).

3 **Adjust the top layer:** An advantage of using Photoshop to create a double exposure is that you can easily adjust the placement of the top image in relation to the base image.

4 **Change the opacity:** You can change the opacity of the top layer easily with the layer opacity tool shown in **Figure 3.3**. Reduce the opacity enough to allow the base layer to show through.

5 **Mask unwanted areas:** You can remove unwanted areas in the top image by adding a layer mask and then painting over the unwanted areas with black. The bottom layer will show through wherever you paint the mask. See the sidebar titled "Photoshop Masks" for more information on how to apply a mask.

6 **Change the top layer's blend mode** (**optional**): The blend mode determines how the top and bottom layers interact. There are 27 different blend modes in Photoshop, but it's easier to break them into six groups.

I recommend experimenting with the different blend modes to get a feel for how each one affects your images:

Normal: The first two blend modes are Normal and Dissolve. Normal is the default mode when you open an image. The two layers are not blended together at all. Dissolve acts on transparent and semitransparent pixels, allowing parts of the base image to come through.

Darken: Darken, Multiply, Color Burn, Linear Burn, and Darken Color all make the final image darker, but each has a different visual effect.

Lighten: Lighten, Screen, Color Dodge, Linear Dodge, and Lighter Color all make the final image lighter, but each has a different visual effect.

Contrast: Overlay, Soft Light, Hard Light, Vivid Light, Linear Light, Pin Light, and Hard Mix all lighten the lighter pixels and darken the darker pixels, creating contrast in the final image.

Inversion and Cancelation: Difference, Exclusion, Subtract, and Divide make up this group. These can really give the two layers a very interesting look as they perform mathematical equations on the pixels in both layers.

Component: Hue, Saturation, Color, and Luminosity adjust the color of the layers and how they interact.

As I mentioned, these are just the basic steps to combine two exposures into a single image in Photoshop. There is a lot more that you can do to create double exposures in Photoshop, and there are many great Photoshop books out there that will allow you to explore this further.

3.1 The very talented Jennifer and an image of her feet on pointe, combined into a single frame in Photoshop.

3.2 Two images opened in Adobe Photoshop with the second image positioned over the first.

3.3 The opacity slider controls how much of the selected layer is visible. You can adjust it anywhere between 0% and 100%.

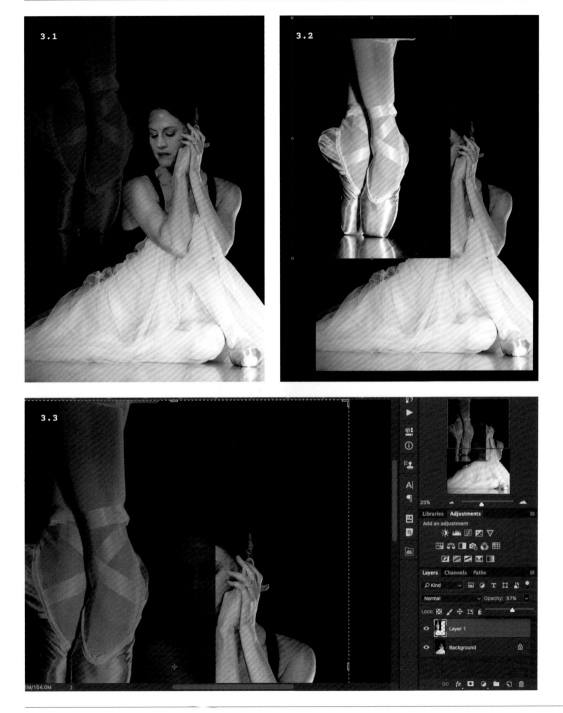

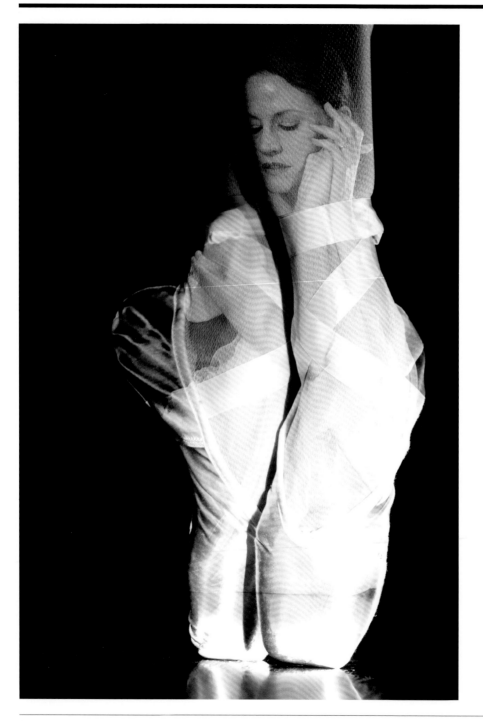

3.4 By changing the order of the two images and using the Overlay blend mode, I was able to create a very different double exposure with the same two images.

Creating a Layer Mask in Photoshop

In Adobe Photoshop, one of the most powerful tools for creating double exposures is the Layer Mask tool. This tool allows you decide which parts of the top layer are visible and which parts are transparent, allowing the layer beneath to show through. To create a layer mask all you have to do is click on the Add Mask button at the bottom of the Layers palette (**Figure 3.5**).

The new layer mask is filled in with white and does not allow any of the underlying layer to show through, so it looks as if nothing has changed. If you want to mask out a portion of a layer, make sure the layer is selected (it has a white border, as seen in **Figure 3.6**), and then just paint out the parts you want to be hidden using a paintbrush set to black.

You can see the Layers palette with the layer mask in place in **Figure 3.7**. The areas of the layer mask that are black allow the underlying layer to be seen through the top layer. This is nondestructive editing because you can always paint over the black areas with white and vice versa.

3.5 The Add Mask button at the bottom of the Layers palette.

3.6 The selected layer mask with the white border.

3.7 The layer mask in place.

4. USING A FLASH TO CREATE DOUBLE EXPOSURES

ANOTHER GREAT METHOD for creating a double exposure look involves using a light painting technique to illuminate multiple subjects in the same exposure. You leave the shutter open and use a light source—such as a flash, a flashlight, or even a studio strobe—to illuminate the parts of the scene you want the camera to record. The "double exposure" part comes into play because you can move or change the subject or add new elements to the image during the exposure and expose the same area to light twice during a single exposure. Back when I was in college, I used this technique to take portraits of people talking to themselves on a single frame of film. It's fun to create these images and you can get really interesting results. **Figure 4.1** shows a self-portrait I created in my living room with a camera, a tripod, and a single Nikon Speedlight.

The key to this technique is to keep the shutter open during the entire exposure and both flashes of light by using the Bulb shutter speed. Most DSLR cameras have a wide range of shutter speeds, from 1/4000 second all the way to 30 seconds, and a Bulb mode. The Bulb mode (depicted by the letter B or the word Bulb on the shutter speed display, as shown in **Figure 4.2**) allows the shutter to stay open for longer than the 30-second max that most DSLRs allow. It will remain open for as long as the shutter release button is pressed down. If you are using a remote shutter release, you can lock it so that the shutter stays open without you having to keep your finger on the shutter release button during the exposure. As a Nikon user, I use the MC-36 Multi-Function Remote Cord with my Nikon D4 (**Figure 4.3**) because it allows me to do more than just trigger the shutter. You can use any camera remote that allows you to trigger and lock the shutter release.

When the shutter is open, light is allowed to enter the camera, so I have two main tips that will help you create successful images with this technique. The first is that it helps to work in a very dark area. The second is to use something to cover the front of the lens to block the light between the "exposures." You will want to block any light from entering the lens. I usually make a homemade lens cover that goes over the whole front of the lens (**Figure 4.4**). I start by cutting a cardboard circle a little bigger than the front of my lens, and then I cover it in black gaffer tape. I use the tape to make a big lip around the cardboard so that I can slip the cover over the front of the lens as shown in **Figure 4.5**. The cover doesn't have to be pretty, but it does need to block out light and it should be easy for you to put it on the lens and take it off without moving the camera.

You can also cover just part of the lens with a piece of black poster board when you fire the flash to block the light from portions of the scene. This prevents the light from reaching the sensor.

If the two exposures (i.e., the two flashes) are going to take place in the same area, it's helpful to use a tripod to keep the camera steady. I like to set up the scene and then lock the camera into position so that the only thing that changes between the two flashes is the main subject. This adds a sense of realism to an unrealistic scene.

Follow these steps to create a double exposure using a flash:

1. Attach a cable shutter release to the camera.
2. Set the shutter speed to Bulb.
3. Set the ISO as low as possible (ISO 100).
4. Set the aperture to f/16.
5. Mount the camera on a tripod and compose the scene.
6. Focus on the subject, then switch the camera to manual focus so that it doesn't change focus when you take the photo.
7. Turn off all the lights to make the scene as dark as possible.
8. Press and lock the shutter release button on the cable release to open and lock the shutter.
9. Light the subject with the flash.
10. Cover the lens.
11. Move the subject.
12. Uncover the lens.
13. Light the subject a second time.
14. Close the shutter.

The resulting image is a single frame with two exposures created by the flash, as seen in **Figure 4.6**.

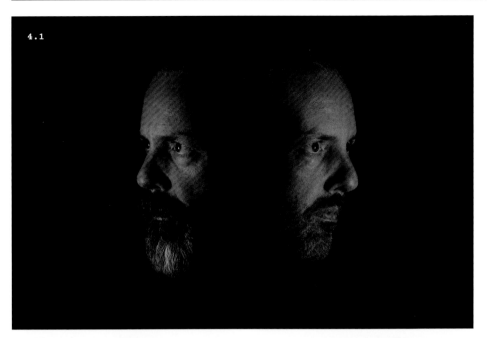

4.1

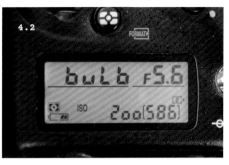

4.2

4.1 I used a Nikon Speedlight to illuminate myself two times during a single exposure.

4.2 The Bulb shutter speed shown on my Nikon D750.

4.3 The Nikon MC-36 Multi-Function Remote Cord. This remote allows me to lock the shutter open when the camera shutter speed is set to Bulb.

4.4 A homemade lens cover used to block out light.

4.5 The lens cover on a 24-70mm f/2.8 lens.

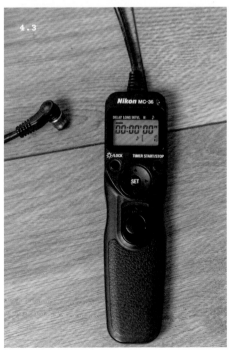

4.3

4.4

4.5

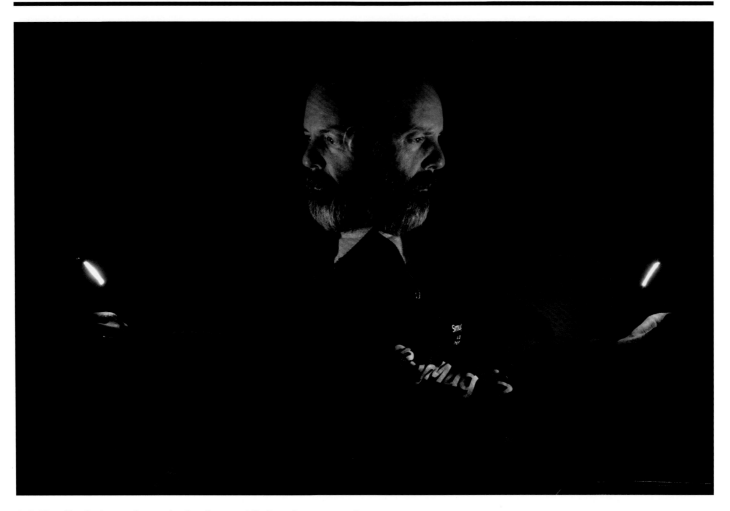

4.6 The final image is a single frame with two "exposures."

One of the great things about digital cameras is that they provide instant feedback so you can see how the image came out immediately. This allows you to experiment with the light placement, the position of the subject, and the power of the flash. Adjusting the power and direction of the light source allows you to fine tune the image and change how the subject looks. If there is too much light bleeding over to where the subject was positioned in the first frame, the background will show through the subject, making it look like a ghost (**Figure 4.7**).

This technique is a lot of fun to experiment with. Although it is technically not a double exposure, you can get the overlay effect by moving not only the subject but the camera as well. Just make sure that you cover the lens while moving the camera or the subject. To create **Figure 4.8** I moved the subject from one side of the frame to the other and I also moved the camera.

I know some of you are probably thinking that you can do this very easily with Photoshop or another image-editing program, and I agree; it is easy to do this in Photoshop. But there is something viscerally rewarding when you create this effect in the camera.

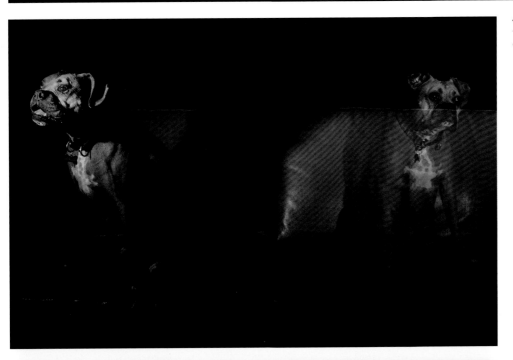

4.7 Allowing the light to bleed through the first exposure creates a ghostly image.

4.8 If you move both the subject and the camera you can create a very interesting double exposure effect with just a couple of flashes from a Speedlight.

5. FINE-TUNING THE EXPOSURE WHEN SHOOTING DOUBLE EXPOSURES

FOR A STANDARD photograph, a proper exposure is when just the right amount of light passes through the lens to the sensor when the shutter is moved out of the way. If too much light reaches the sensor, the image is too bright; if not enough light reaches the sensor, the image is too dark. The image is properly exposed when there is enough light to show both the light and dark areas in the image without the subject being too bright or too dark. When you combine two photos in-camera, the exposures of the two photos are added together and the amount of light is cumulative; therefore, the exposure settings for both photos is important.

As I mentioned earlier in this chapter, understanding how the two exposures interact gives you control over which parts of each image will show in the final double exposure. The areas that are exposed to a lot of light in the first image will allow less of the second image to show, while areas that are exposed to just a little light in the first image will allow more of the second image to show. Many cameras try to help you achieve the correct exposure for multiple exposure images by using the auto gain feature. Auto gain works by reducing the exposure of the individual images so that the combined exposure is more balanced. The downside of this feature is that it can add noise to the image, and it doesn't work great for subjects with dark backgrounds. Of course, you can also control the exposure of the images yourself by shooting in manual mode and turning the auto gain feature off.

The first thing to determine is the amount of light that is needed to make a proper exposure for each image. With the metering mode, exposure mode, and exposure compensation controls you can adjust how the camera will expose the scene (see the sidebar titled "Exposure Basics"). After you've determined the proper exposure, you can then underexpose or overexpose each individual image based on how you want the final combined image to look. If you want more of the second image to show, you need to underexpose the first image. The easiest way to do this is to use your camera's exposure compensation setting and make sure that auto gain is turned off.

Most of the time, I actually want to overexpose the first image to make the background pure white (**Figure 5.1**). I start by positioning my camera so that my subject is in front of the sky or a light background, and then I use spot metering to make sure my exposure settings are calculated based on the subject and not the sky. I use the aperture priority mode so that I can control the depth of field, and the camera sets the shutter speed. I then adjust the exposure with the exposure compensation control so that the image is slightly overexposed. This turns the background as close to pure white as possible. You can take test shots before you create the double exposure to see how the first image will look.

TIP: Turn on the highlight clipping warning (the blinkies) on the camera LCD so that you can quickly see what areas of your image are pure white.

After you've taken the first image for your double exposure, you need to adjust the exposure for the second image. For the second exposure, I usually stick with the aperture priority mode, but I tend to dial the exposure compensation down to 0 or even −1 (**Figure 5.2**).

These settings will give you a great starting point and allow you to easily fine-tune the exposures with the exposure compensation control.

5.1 The first image is overexposed—the background is pure white.

5.2 The second image is slightly underexposed.

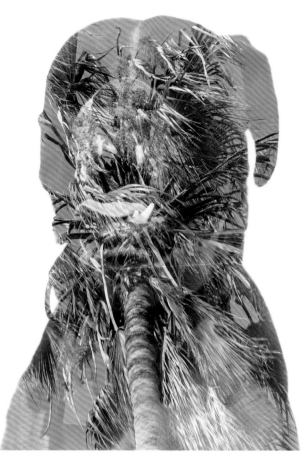

5.3 The combined image is properly exposed and has a white background.

Exposure Basics

A correct exposure is when enough light reaches the sensor so that the image is not too dark or too light. There are three controls that affect the exposure: the shutter speed controls the length of time the sensor is exposed to light; the aperture is the size of the opening in the lens that lets lights through, and thus controls the amount of light that is allowed to reach the sensor at once; and the ISO determines how much the light that reaches the sensor is amplified. The more the light is amplified the less light is needed to create a proper exposure. However, a high ISO also introduces noise into the image.

Digital cameras have a built-in light meter that measures the available light in a scene and tells the camera what the exposure should be. Most cameras have more than one light meter mode, so you can choose whether you want to measure the light in the whole scene or just part of the scene:

- **Matrix Metering (Figure 5.4):** In this mode, the camera measures the light in the whole scene. This mode has different names depending on the camera manufacturer, but the way it functions is similar across makes and models. The camera evaluates the bright and dark parts in the scene and tries to determine the proper exposure settings. This works really well for most scenes, but not all.

- **Center-Weighted Metering (Figure 5.5):** This mode measures the light in the center of the frame and ignores the edges of the scene.
- **Spot Metering (Figure 5.6):** This mode measures the light in a small, targeted area of the scene to determine the exposure settings. I really like using this mode when I'm creating in-camera double exposures because I can determine the exposure settings needed for a particular area of the scene.

The next step is deciding which exposure mode to use. There are four exposure modes on all DSLR cameras:

- **Program Auto:** In this mode, the camera sets the shutter speed and the aperture based on the information it receives from the light meter. This gives a lot of control to the camera and very little to the photographer.
- **Shutter Speed Priority:** In this mode, the photographer sets the shutter speed and the camera sets the aperture.

- **Aperture Priority:** In this mode, the photographer sets the aperture and the camera sets the shutter speed.
- **Manual:** In this mode the photographer sets both the shutter speed and the aperture.

The final piece of the puzzle is exposure compensation. Most cameras have an exposure compensation control that allows you to deliberately over- or underexpose an image by adjusting the current exposure settings along a +/− scale. When you move the exposure compensation toward the positive end of the scale, more light is allowed to reach the sensor and your image will be overexposed in some areas. When you move it toward the negative end of the scale, less light reaches the sensor and your image will be underexposed in some areas.

The following three images were taken at a normal exposure (**Figure 5.7**), +2 exposure compensation (**Figure 5.8**), and −2 exposure compensation (**Figure 5.9**).

5.4 Matrix metering measures the light in the whole scene to determine the settings needed to properly expose the image.

5.5 Center-weighted metering uses most, but not all, of the scene to determine the exposure.

5.6 Spot metering uses just a small portion of the scene to determine the exposure.

5.7 At the proper exposure, there is detail in both the light and dark areas of the image.

5.8 I overexposed the image by two stops, meaning that the bright areas are very bright, even pure white in some spots.

5.9 I underexposed the image by two stops. There is no detail in the dark areas of the image and the bright areas are now pretty dark.

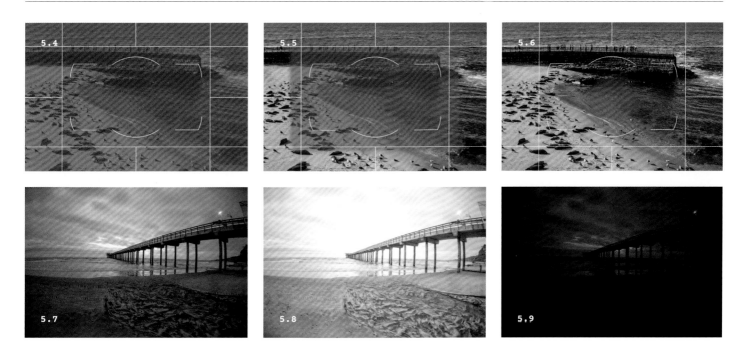

6. CREATING DOUBLE EXPOSURE PORTRAITS

DOUBLE-EXPOSURE PORTRAITS ARE a lot of fun to create and have become very popular. You can even see this effect in some current product advertisements and on movie posters. You get the best results when the first image—that of the person—is shot against a solid white background so that the details from the second photo fill in the silhouette of the person. I prefer to photograph the person either straight on (**Figure 6.1**) or in profile (**Figure 6.2**).

The important thing to remember when shooting the first image is that the light areas in the image will not allow much of the second photo to show while the darker areas will allow more of the second image to show.

When you shoot the second image, try to align the subject matter with where the face was positioned in the first image. You can do this in the camera or you can do it in post-production, but I prefer to try and get the shots aligned in the camera first.

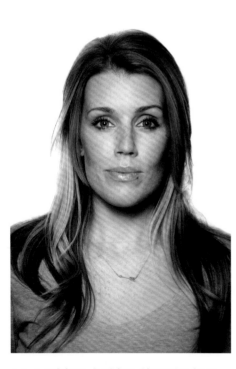

6.1 A subject looking directly into the camera.

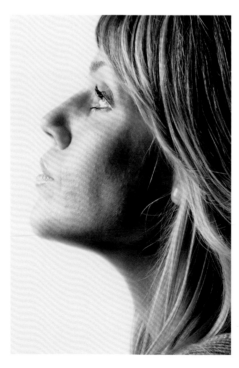

6.2 A strong profile against a white background.

6.3 The trees are much easier to see in the heavy beard.

For **Figure 6.3** I combined a self-portrait with some trees. Because I had a heavy beard in the image and that area of the image was darker, that is where the trees are most visible.

In **Figure 6.4** the profile makes it easy to blend the buildings and the hair together, creating an interesting portrait. The first photo was overexposed by one stop to get the pure white background, and the second photo of the buildings was underexposed slightly to allow the two images to blend together properly.

6.4 Buildings and people can really go well together.

7. USING DOUBLE AND MULTIPLE EXPOSURES FOR ACTION SCENES

AS AN EVENT photographer, I often shoot electronic dance music shows where it's more important to capture the stage lighting and the audience than the actual performance. The lighting at these shows changes really fast and a single frame doesn't quite capture the feel of the event. I often use multiple exposures to capture several lights in the same scene (**Figure 7.1**).

It is also fun to create double exposures of the crowd because they show the motion, excitement, and action of the even. For **Figure 7.2** I combined two exposures in-camera to give the scene a little more pop and excitement. I did not use a tripod but I kept the camera as steady as possible and aimed it at the same spot for both exposures.

Another popular technique for creating action shots is to capture a subject in a series of images as they move across the frame. The sequence of images is then combined so that the subject appears in multiple locations and positions in a single frame. When you shoot the images the camera cannot move at all, so I recommend setting up your shot and using a tripod to keep the camera steady. The following tips will help you to make the final shot more successful:

- **Shoot in Manual exposure mode.** In Manual mode, the exposure settings don't change without you intentionally changing them. This means that the exposure will remain exactly the same for all of the images in the sequence, making it a lot easier to combine them into a single frame.
- **Shoot wide.** Shoot with a wider angle, at least to start with, so that you can practice getting the entire action sequence into the frame. Remember that the camera can't move so you can't track the action. All of the action needs to look as if it were shot in a single frame, so the combined frame needs to include both the start and end points.
- **Shoot as many frames as possible.** You should shoot as many frames as possible between the start of the action and the end of the action. You may not need or want to use all of the shots, but it is better to have too many than too few.
- **Use manual focus.** Set the focus manually before you start to shoot. If you use autofocus, the camera could change focus midsequence if the subject moves out of the selected focus areas.

After you shoot the series of images, open the files as a stack in Photoshop [Files > Scripts > Load Files into Stack], with each image on its own layer. Then use layer masks to allow the subject to come through each layer (see the sidebar titled "Creating a Layer Mask in Photoshop").

Figures 7.3–7.5 show some of the individual frames I used to create the action sequence shown in **Figure 7.6**.

To create this effect I layered the images in Photoshop and masked out the areas in each frame so that only the subject would show. In **Figure 7.7** you can see the layers I used to create the final image and where I masked each layer.

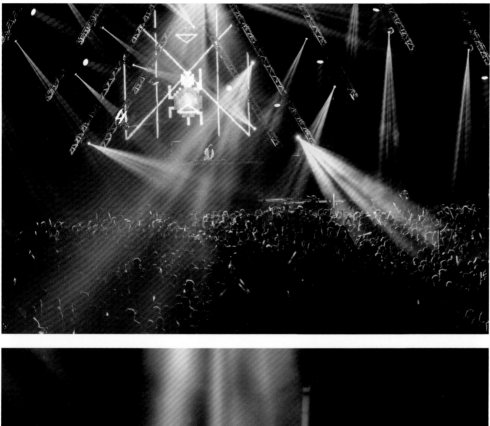

7.1 A double exposure allowed me to capture several lights in one scene.

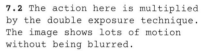

7.2 The action here is multiplied by the double exposure technique. The image shows lots of motion without being blurred.

7.3 The individual frames I used to create the final image.

7.4 You can see the subject moving across the frame.

7.5 This technique works best when there is some distance between the subject's location from one shot to the next.

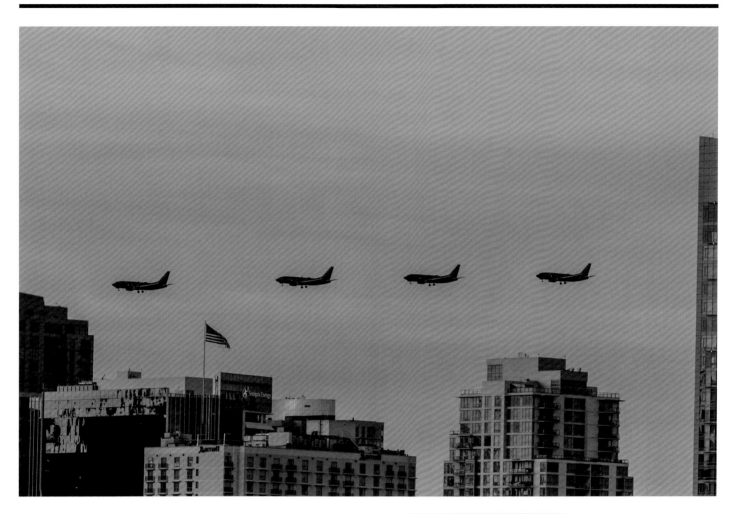

7.6 The final image shows the same subject in multiple spots in the frame.

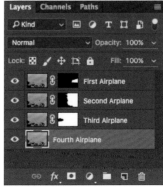

7.7 The masks used in Adobe Photoshop to create the final image.

8. VARYING THE WHITE BALANCE IN MULTIPLE EXPOSURES

THE WHITE BALANCE setting controls the overall color of a photo. While our eyes constantly adjust to the color of the light in any environment, cameras do not. You need to tell the camera about the type of light in which you are shooting so that the camera renders the colors properly. You do this by setting the proper white balance, or color temperature. You can also add a different color tone to an image by adjusting the white balance setting. This effect can be really interesting when you shoot in-camera double exposures because you can give each individual frame a different color cast.

You can adjust white balance manually, or choose from a selection of settings based on lighting type:

- **Kelvin:** This setting allows you to manually input the color temperature of the light. The lower the number, the warmer the light; the higher the number, the cooler the light.
- **Tungsten:** The light from tungsten bulbs is really warm so this setting adds some blue back into the image.
- **Fluorescent:** Fluorescent lights run the gamut from very warm to quite cool. This setting adds a little blue into the image as needed.
- **Daylight and Flash:** These two settings are really similar, which makes sense because flash manufacturers try to make the light from the flash as close to natural daylight as possible. The light from the flash is still slightly warm, so these settings both add a touch of blue to even out the color.
- **Cloudy:** The light under a cloudy sky is slightly cool so this setting adds in some red/orange to provide warmth.
- **Shade:** The light in the shade has a blue tone so this setting adds some red/orange back into the image. The shade setting adds more warmth than the cloudy setting.

There are a few really fun visual effects you can create by shooting the exact same scene with two different white balance settings. To create **Figure 8.1**, for example, I shot one image with the tungsten white balance setting and one with the flash setting and then combined them.

You can also use this technique to render a more natural-looking image by combining portions of multiple frames of the same scene shot under different light sources—for example, an interior of a room with both incandescent bulbs and sunlight coming in through a window (**Figure 8.2**).

- Position your camera on a tripod and shoot the same scene several times, changing the white balance with each exposure.
- Open the files as a stack in Photoshop: [Files > Scripts > Load Files into Stack].
- Mask different areas in each layer to allow the different colors to show through where you want them to (**Figure 8.3**; see the sidebar titled "Creating a Layer Mask in Photoshop").

You can also use this technique to add surreal colors to your images by using a white balance setting that does not match the light source under which you shot the images. In **Figure 8.4** I used two exposures of the same scene, one with the proper white balance, and the other with a tungsten white balance, which gives a very different color cast.

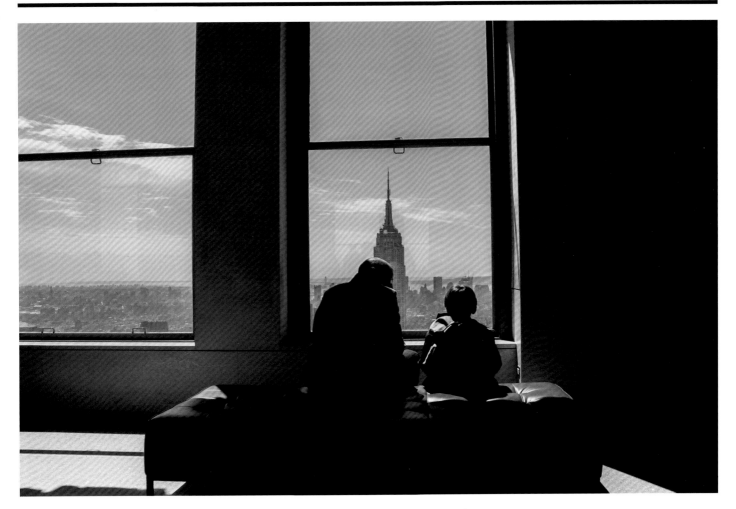

8.1 Combining two images allowed me to have two white balances in the same image.

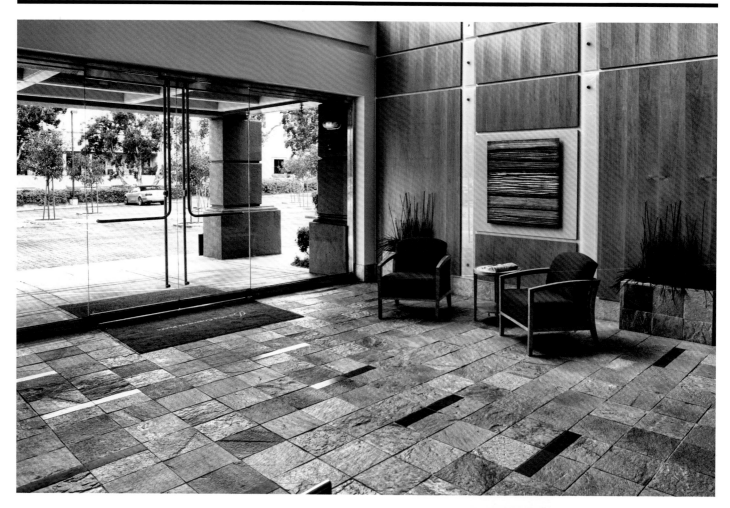

8.2 The final image showing the blended white balances.

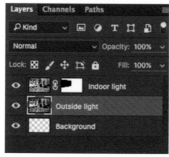

8.3 The stack of layers in Photoshop showing the masked areas.

8.4 Blending two images with very different color casts can create a really interesting image.

9. THE ADVANTAGES AND DISADVANTAGES OF USING MORE THAN TWO EXPOSURES

AS I DISCUSSED in the beginning of this chapter, when you create multiple exposure images you are not limited to just two exposures—you can use as many as you want. Some techniques, like those used for action sequences or to reduce digital noise, require much more than just two images. Many of the cameras that allow for in-camera multiple exposures let you use more than two images, but it depends on the camera model. For example, the Nikon D4 allows you to combine up to nine images in-camera while the Nikon D750 only allows for three. You can combine an unlimited number of images in post-production.

The number of images you need to create a multiple exposure image will depend on the subject and the technique. For some techniques, 10 or 15 exposures might just be the start. For creating in-camera multiple exposures, I like to stick with two images. While I realize this may sound contradictory, I believe the most effective multiple exposure images are those that are simple (**Figure 9.1**). Sometimes using too many images can take the image from interesting to confusing.

Share Your Best Double Exposure!

Once you've captured your best double exposure, share it with the *Enthusiast's Guide* community! Follow @EnthusiastsGuides and post your image to Instagram with the hashtag *#EGDoubleExposure.* Don't forget that you can also search that same hashtag to view all the posts and be inspired by what others are shooting.

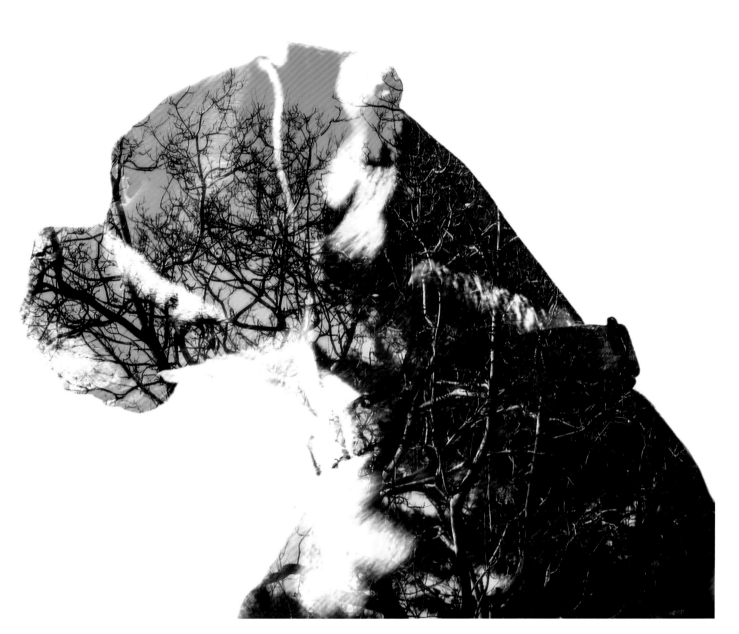

9.1 I used just two exposures to create this image of my dog, Maggie.

2

HIGH DYNAMIC RANGE PHOTOGRAPHY

High dynamic range (HDR) photography is a technique in which you take a series of images at different exposures and blend them together to create a single image that has a wider dynamic range than is possible in any individual exposure. This technique can be used to create both images that look very natural and images that look like vibrant pieces of pop art. Many photographers tend to dismiss HDR as being overly fake or unrealistic. The truth is that you can use HDR techniques to create just about any kind of image you want. Many times people looking at my HDR images don't realize that I created them by blending multiple exposures.

10. HDR BASICS

BEFORE WE CAN start creating HDR images we really need to take a step back and discuss what dynamic range is and why we need multiple images to create high dynamic range photos.

The dynamic range of an image is the range of light intensities between the brightest and darkest areas of the image. When we look at a scene, our eyes and brain work together to allow us to see detail in both the brightest and darkest areas at what seems to be the same time. This isn't exactly true; our eyes look around the scene and as we look at the bright areas our pupils contract to let in less light, and then as we look at the darker areas they expand to let in more light. This happens pretty fast and our brains interpret the data constantly, so it seems like we're able to see detail in both the bright and dark parts of a scene at the same time.

A camera is not that smart and can only capture a specific range of values. If you set your camera's exposure settings to capture the details in the brightest areas of a scene, the dark areas could get too dark and lose detail if they exceed the range of light values that the camera is able to capture. Or you could set the camera to capture the details in the dark areas and the bright areas could lose detail. The idea behind HDR photography is to take a series of photos that covers the full dynamic range of a scene and then blend them together so that there is detail in both the dark and light areas in the final image (**Figures 10.1–10.3**). This is a lot like how our eyes work.

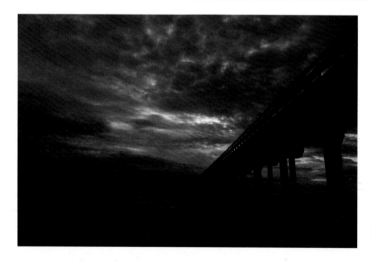

10.1 In this photograph of the Scripps pier there is detail in the sky, but the area on the ground and underneath the pier is underexposed.
ISO 400; 1/30 sec.; f/16; 24mm

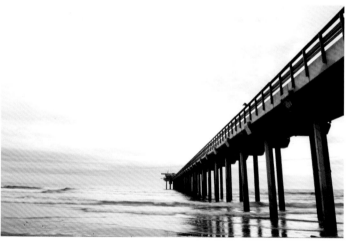

10.2 In this photograph the areas that were dark in the previous image are now visible, but the sky is overexposed and has lost all detail.
ISO 400; 1/2 sec.; f/16; 24mm

In **Figure 10.1** you can see that there is detail in the sky but the ground and the underside of the pier are in heavy shadows and have lost detail. The reverse is true in **Figure 10.2**, where there is detail in the ground and under the pier but the sky is too bright and there is no detail in the clouds. The solution to this problem is to create an image that includes the sky detail from the first image and the shadow detail from the second image. You can see the combined image in **Figure 10.3**.

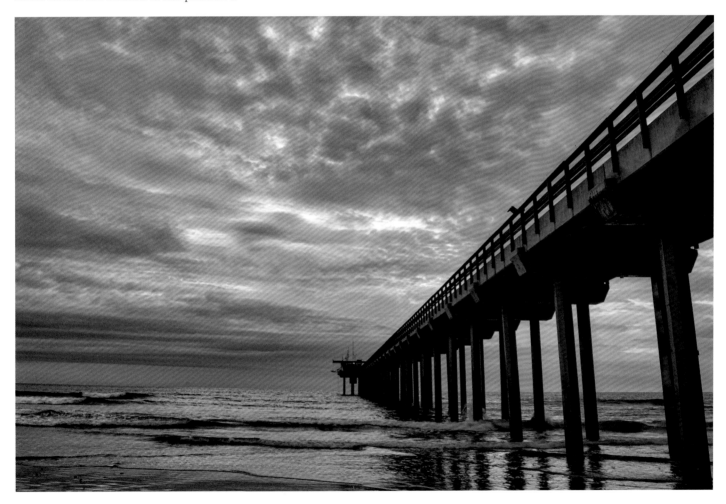

10.3 I combined the two previous images to create this HDR image in which you can see the details in both the bright and dark areas.

11. SHOOT BRACKETED IMAGES

WHEN PEOPLE TALK about HDR photography, one of the first terms that usually pops up is "bracketed images," and for good reason. To create an HDR image, you need to take a series of images that include not only a properly exposed image but also images that are darker and lighter than the proper exposure. This set of images is called a bracket, and the images usually range from underexposed to overexposed.

When you shoot a set of bracketed images you get to decide how much difference there is between each exposure and how many exposures to take. Most DSLR cameras have an automatic bracketing function that will change the exposure for you, but you can also do this manually or with the exposure compensation setting on your camera.

Let's walk through exactly what happens when you take a set of bracketed images. For this example we'll start with an image that is properly exposed at 1/1000 second, f/4.5, and ISO 100 (**Figure 11.1**). To underexpose this image by a single stop, we need to increase the shutter speed to 1/2000 second, which lets in exactly half as much light (**Figure 11.2**). To underexpose the image by two stops of light,

we have to increase the shutter speed to 1/4000 second (**Figure 11.3**). All we've changed is the shutter speed; the aperture and ISO are the same for each image. As you can see, in the two underexposed images the whole scene is darker and we have lost detail in the shadow areas. However, we have increased the detail in the bright areas by making them darker.

We can now increase the detail in the dark areas by overexposing the scene. If we decrease the shutter speed from 1/1000 to 1/500 second, we overexpose the image by one stop (**Figure 11.4**), and if we decrease it a second time to 1/250 second, we overexpose the image by two stops (**Figure 11.5**). We now have a five-image bracket with exposures that range from −2 to +2.

When we combine these five images using HDR software, we get an image that has detail in the lightest and darkest areas. The combined HDR image is closer to what I saw at the scene than any of the five individual images (**Figure 11.6**).

As I mentioned previously, many cameras have an automatic bracketing function that allows you to select the number of bracketed

images in a series and the exposure difference between each image. To capture the photos of the rocks, I set my Nikon D750 to take five images with a one-stop difference between each image. Check the user's manual for your camera to find instructions on how to use its bracketing function.

11.1 The stacked pile of stones properly exposed.
ISO 100; 1/1000 sec.; f/4.5; 35mm

11.2 The stacked pile of stones underexposed by one stop.
ISO 100; 1/2000 sec.; f/4.5; 35mm

11.3 The stacked pile of stones underexposed by two stops.
ISO 100; 1/4000 sec.; f/4.5; 35mm

11.4 The stacked pile of stones overexposed by one stop.
ISO 100; 1/500 sec.; f/4.5; 35mm

11.5 The stacked pile of stones overexposed by two stops.
ISO 100; 1/250 sec.; f/4.5; 35mm

11.6 An HDR image of the stacked rocks created from the five individual frames.

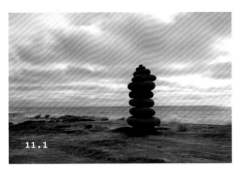

11.1

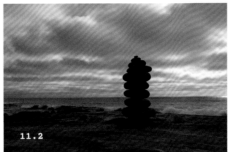

11.2

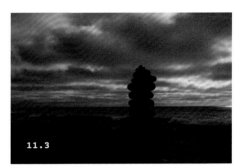

11.3

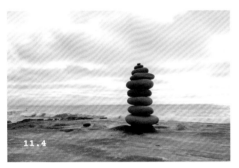

11.4

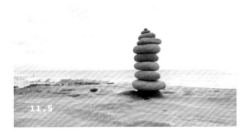

11.5

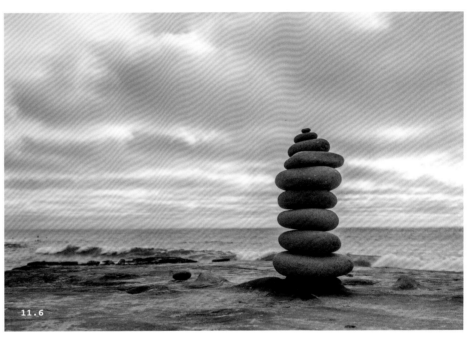

11.6

12. HOW MANY EXPOSURES DO YOU REALLY NEED?

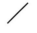

THE MOST COMMONLY asked questions regarding HDR photography are how many images are needed and how much should the exposure vary between each image. There are a lot of different answers to these questions; a lot depends on how you work and what you want to capture. I first started shooting HDR images for a large concert and event venue to document the stage setups in a variety of configurations. Because I only had one chance to get these types of photos, I took nine images at a time with a difference of one stop between each image. This gave me a lot of information for each shot, with the exposures ranging from –4 to +4. The downside was that I had a large number of images to store and it took time to process each set of images to create the final image.

So do you really need to use nine images with a one-stop difference between each image for all of your HDR photos? No, you can get away with using a lot less and still end up with great HDR photos. The minimum number of images you need is three, preferably with two stops between each image; an underexposed image at –2 (**Figure 12.1**), a properly exposed image at 0 (**Figure 12.2**), and an overexposed image at +2 (**Figure 12.3**).

When these three images are combined into a single HDR image, you can see detail in both the bright and dark areas (**Figure 12.4**).

The more exposures you use, the more information the software has to create the final HDR image. In practical terms, I use more exposures when the scene I am shooting has a larger dynamic range. So if I am shooting outside in bright sunlight and there are deep shadows, I'll use nine frames. If I am shooting indoors and there is not a huge difference between the bright and dark areas, I'll use five or even three frames.

One final factor to consider is whether you are shooting the bracketed images handheld. Sometimes I see a scene that requires bracketed images but I don't have a tripod with me and there is no nearby surface on which to rest the camera. In these situations I usually take a three-image bracket with two stops between each image. I find it easier to handhold the camera for three frames in quick succession than five or seven.

12.1 This scene is underexposed by two stops (–2 exposure).
ISO 100; 1/800 sec.; f/8; 70mm

12.2 This scene is properly exposed (0 exposure).
ISO 100; 1/200 sec.; f/8; 70mm

12.3 This scene is overexposed by two stops (+2 exposure).
ISO 100; 1/50 sec.; f/8; 70mm

12.4 The final HDR image created from the three exposures.

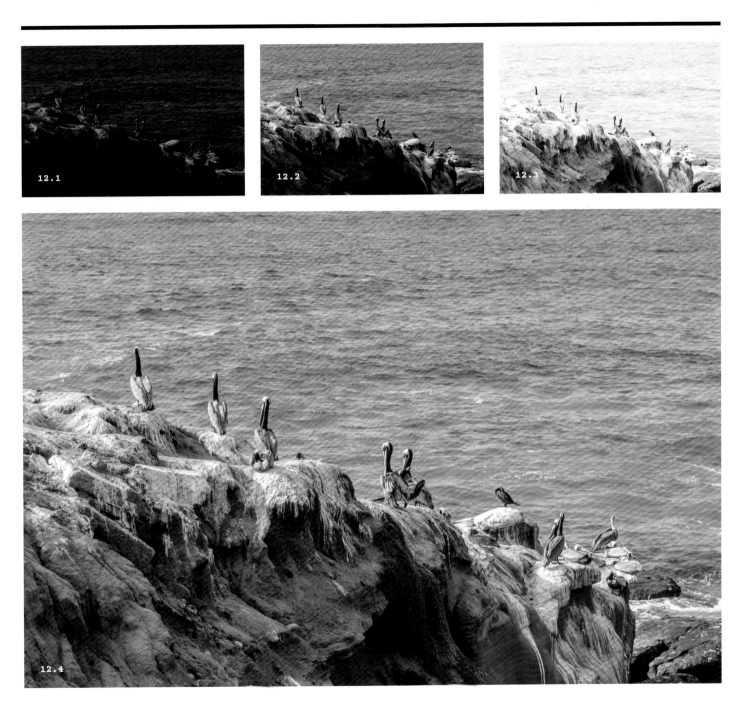

12.1

12.2

12.3

12.4

13. MAKE SURE
YOUR IMAGES ARE SHARP

HDR IMAGES WORK best when each image in the set has the exact same composition, which means you have to make sure the camera doesn't move during the exposures. It is possible to handhold the camera, but it is a lot easier to lock the camera onto a tripod. And if you really want to make sure you get the sharpest images, you need to use a remote shutter release so you can trigger the shutter without touching the camera. Finally, if you have a DSLR, you can use the mirror lockup feature to move the mirror out of the way and lock it in position before opening the shutter.

Tripods

There are thousands of different tripods available to photographers. They come in a wide variety of materials with different leg lengths, leg-locking mechanisms, tripod heads, and price points. You want a tripod that is sturdy enough to support your camera and lens and light enough to carry with you. Generally, the lighter and stronger the material, the more expensive the tripod.

- **Aluminum:** These tripods are a good choice for most people. They are strong and can support a lot of weight, and they are practically vibration-free. However, they can get heavy, especially if you have to carry one a long way. My current travel tripod is a Manfrotto aluminum tripod that can hold more than 19 pounds and weighs 5.5 pounds (**Figure 13.1**).

- **Carbon Fiber:** These tripods are a lot lighter than the aluminum ones, making them much easier to carry over long distances. They can be less stable than other tripods due to their very light weight. These tripods are also the most expensive.
- **Basalt:** Some tripods are now made out of basalt, usually combined with a carbon fiber core, which makes them much lighter than aluminum and cheaper than the full carbon fiber tripods. These tripods tend to be slightly less stable than the aluminum ones, but the lighter weight and lower cost (compared to solid carbon fiber) is worth it.
- **Wood:** Wood is a great material for tripods because it is very stable and naturally dampens any vibrations in the camera. However, these tripods are very heavy and expensive.
- **Plastic:** There are some tripods that are built from mainly plastic pieces. These are usually very cheap and light and are best avoided.

Most tripods come with a center column that allows you to raise the camera up a little higher, but this extra height comes at a price. When the tripod's center column is raised it is slightly less stable than when the camera rests directly on top of the three legs.

There are three basic types of tripod heads:

- **Ball Head:** A ball head allows you to quickly adjust the position of the camera on the tripod. It has a ball and socket that gives it a wide range of motion and allows you to lock the camera into place with a single knob or lever. The downside is that these tripod heads are more expensive and hold less weight than pan and tilt heads of the same size.
- **Video Head:** These are made specifically for recording video and allow you to pan the camera smoothly. They can be used for regular photography as well, but you need to make sure that the head is locked down. These can be much more expensive than regular tripod heads. Unless you are shooting mostly video, these heads are not a great choice for still photography.
- **Pan and Tilt Head:** This is the most common type of tripod head. These heads have three separate controls for locking the camera in position. You can control the left-to-right, up-and-down, and tilt movement of the camera. This is my favorite type of tripod head because it allows for very precise positioning of the camera. The downside is that these heads tend to be bigger than ball heads or video heads and they have multiple arms sticking out. This can add weight and make travel more difficult. You can see the pan and tilt head on my tripod in **Figure 13.2**.

When choosing a tripod, you need to make sure that it will support the combined weight of your camera, lens, and the tripod head. Most tripod manufacturers state the maximum weight a tripod can hold. You also need to consider the maximum weight that the tripod head can

hold. There is no point in getting yourself a great tripod if you're going to use a cheap, plastic tripod head.

Remote Shutter Release

Let's say your camera is set up on a tripod to keep it rock steady during an exposure and then you press down on the shutter release button to take the actual photo. That little push on the camera can create small vibrations that cause the camera to shake slightly during the actual exposure, resulting in a blurry image. To keep the camera as steady as possible, it's best to use a remote shutter release to trigger the shutter. This way you can take the photo without actually touching the camera.

Check your user's manual to find out which type of remote release will work for your camera. I work with Nikon cameras and use the MC-36 Multi–Function Remote Cord for the cameras that have a 10-pin connector because

it allows me to keep the shutter open for long periods of time (discussed in chapter 1) and it allows for time-lapse photography (chapter 5). When I use my Nikon D750, the ML-L3 Wireless Remote Control works great (**Figure 13.3**).

Mirror Lockup

If you're using a DSLR, the final step for getting the sharpest image possible is to move the mirror up and lock it in place before you take a photo. Normally when the mirror moves up and out of the way before the shutter opens, it can cause small vibrations inside the camera. When you lock the mirror up there is time for the vibrations to die down before the shutter is released and the image is recorded.

Every camera does this a little differently, so it's best to check your user's manual for instructions on how to lock up the mirror before taking a photo. In **Figure 13.4** you can see the M-UP mode on my Nikon D750.

13.1 My current tripod is an aluminum model that is very stable and weighs under six pounds.

13.2 The pan and tilt head has three controls that allow you to fine tune the position of the camera.

13.3 With the ML-L3 Wireless Remote Control I can trigger the shutter of my Nikon D750 wirelessly.

13.4 The M-UP control on the Nikon D750 locks up the mirror the first time you press the shutter release, and then moves the shutter out of the way the second time you press the shutter release.

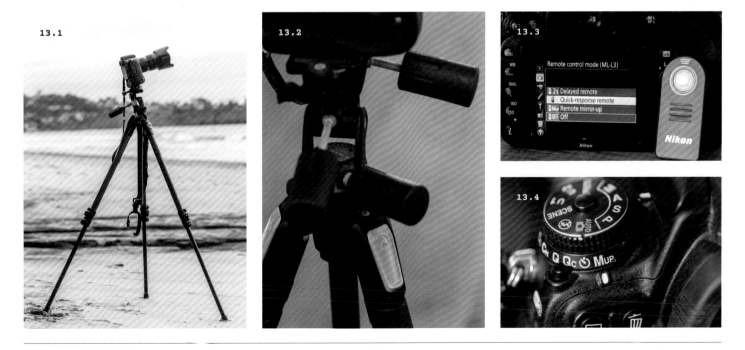

13.1

13.2

13.3

13.4

14. APERTURE PRIORITY MODE WORKS BEST

THE APERTURE IS one of the main factors that controls the depth of field in an image, which is the area that is in acceptable focus. If you use different apertures to shoot the individual frames for an HDR image, the depth of field will be different in each frame, which will cause blurring in the final combined image. It's best to use Aperture Priority (A) mode to maintain a constant aperture for each frame in the set.

In **Figures 14.1** and **14.2** you can see the same scene, photographed first with the same depth of field used for each frame, and second with a different depth of field used for some frames. Notice that **Figure 14.2** is somewhat blurry.

So if the aperture is constant, then it is the shutter speed that needs to be adjusted for each frame. This can cause issues, especially in lower light situations when the shutter speed drops so low that you can't keep the camera steady handheld. This is one of the main reasons you need to use a tripod whenever possible.

When you use a slow shutter speed, you can also run into problems if the subject moves between frames. Luckily, camera and software engineers have built in algorithms to counteract the slight movement of subjects between frames. We'll discuss this more when we cover software-specific techniques later in the chapter.

14.1 I used the same aperture, and thus the same depth of field, to shoot each individual frame that makes up this HDR image.

14.2 I changed the aperture, and thus altered the depth of field, for some of the frames that make up this HDR image. The red arrows point to areas that are now blurred in the image.

15. WHAT TO METER (AND FOCUS) ON

YOUR PHOTOGRAPHS SHOULD tell a story, or at least keep the viewers' attention. This means that you need to make sure the focus is on the subject at which you want the viewer to look, and that the important parts of the image are properly exposed. You may think that shooting a bracketed set of images means that you don't have to worry about exposure, but that's not true; you still need to make sure that the final image is properly exposed.

In chapter 1, I covered the three main metering modes: matrix metering, center-weighted metering, and spot metering. Matrix metering works really well for most of the images I take, but when you are shooting a bracket for an HDR image, I suggest using spot metering. This is a tip I learned from photographer RC Concepcion, who made the great point that when you use spot metering you can decide exactly what the camera is going to expose for, and then the bracket will be built around that.

Most new DSLRs tie the spot metering area to the selected focus point, which means that the camera measures the light in the exact area where you are focusing and bases the exposure around that area. This is fantastic because it ensures that the area of focus is properly exposed. In **Figures 15.1** and **15.2** you can see the focus points and the areas the camera used to meter the light.

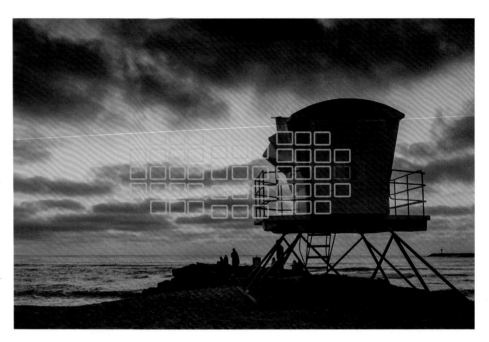

15.1 For this image I focused on the lifeguard tower. The camera used this area to meter the light.

15.2 For this image I focused on the wall below and to the right of the people. The camera used this area to meter the light.

16. USE IN-CAMERA HDR TO EVALUATE THE SCENE

SOME CAMERAS ALLOW you to shoot a series of frames and combine them in the camera to create an HDR image without the need for any post-processing or special software. The upside to this is that you can create an HDR image right there on the spot. The downside is that you don't have much control over how the final image looks. The camera software will take the bracketed images and blend them together to create an image that has a wider dynamic range than any of the individual frames in the bracket.

The best reason to use the in-camera HDR setting is to quickly evaluate whether the scene you are shooting will make a good HDR image. If the in-camera version looks good, you can go ahead and take a complete set of bracketed images and create a full HDR image on the computer.

The Nikon HDR setting works only with JPEGs and gives you very little control over how the final image looks. When you press the shutter release button in HDR mode, it seems like the camera is taking a single photo, but in reality it records the scene with three different exposures and then combines them in the camera. You can set the strength in a range from Low to Extra High, or set the function to Auto. As you can see in **Figure 16.1**, the in-camera HDR image is not terrible, but this feature doesn't give you the level of quality or control over the scene that you have when you shoot a three-image bracket and combine the frames with specialized software (**Figure 16.2**).

If your DSLR doesn't have the ability to make an HDR image in the camera, don't worry, your smart phone probably does. Apple added an HDR function to the camera on both the iPhone and iPad, and there are numerous apps that allow you to create HDR photos on both Apple and Android devices. Most of these apps allow you to take a photo and see what the scene looks like in HDR.

16.1 This image was created with the in-camera HDR setting with the strength set to Extra High.

16.2 This HDR image was created from a three-image bracket processed in Aurora HDR Pro.

17. WHAT IS TONE MAPPING?

IN THE BEGINNING of this chapter I explained the basics of HDR photography, where you take a set of bracketed images to capture all of the details in both the darker and lighter areas of your scene. When you use HDR software to combine these images into a single photograph, you get a 32-bit file that has a larger dynamic range than what can be printed or displayed on a computer monitor. The file contains all of the color information, but not all of it can be seen. To address this issue, you need to map the tonal range of the 32-bit file to a smaller tonal range that can actually be seen on a screen. Tone mapping allows you to determine how the tones in the 32-bit image are mapped to an 8- or 16-bit image.

When you map the tones in an image evenly, the image will look quite flat. HDR software allows you to control how the tone map looks. Each of the HDR software programs tone maps slightly differently. I'll walk you through this process in lessons 18 through 20 and explain how to use some of the different HDR software available. The different settings used to create the tone map are the start of how the HDR image will look.

Take a look at the warehouse in **Figure 17.1**. The dynamic range of the scene was far wider than what the camera could see, what the monitor could show, and what could be printed on the page. Tone mapping allowed me to create an image where you can see the details in the shadows inside the building and in the bright areas of sunshine outside the building. The same scene looks a little different when tone mapped with Adobe Photoshop, as you can see in **Figure 17.2**.

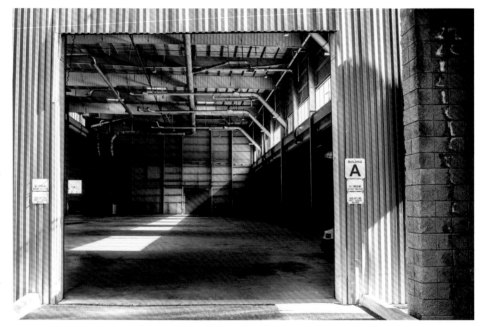

17.1 An image of a cool old warehouse created with a five-image bracket. There was a one-stop exposure difference between each frame and the image was tone mapped in Aurora HDR Pro.

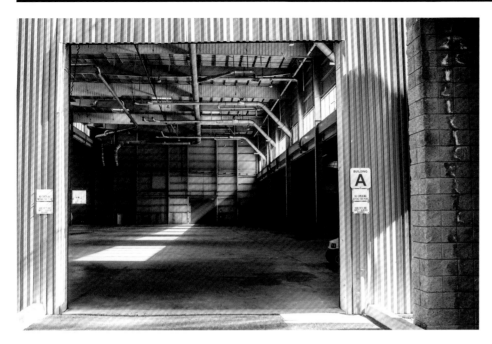

17.2 The same five-image bracket, tone mapped in Photoshop CC.

Bit Depth

There are many aspects of digital photography that have a lot less to do with taking photographs and more to do with the math and technology needed to create the final image. One of those subjects is the use of 8-bit, 16-bit, and 32-bit images. Bit depth (bits-per-channel) controls how many colors there are in an image—the greater the bit depth, the more colors there are in the image. In an 8-bit image, there are 256 colors per pixel, which allows for 16 million possible tones. A 16-bit image has 65,536 colors per pixel, which allows for 280 trillion possible tones. Both of these bit depths are used for normal image editing. The larger 32-bit images are used for HDR photography because they allow for a basically unlimited number of possible tones, more than what can be printed or seen on a monitor. Tone mapping takes a 32-bit image and maps it to an 8-bit or 16-bit image.

18. CREATING AN HDR IMAGE IN PHOTOSHOP CC AND ADOBE CAMERA RAW

THERE ARE MANY different HDR software options available for photographers. With the latest versions of Photoshop, you can create and edit 32-bit HDR images in Photoshop and in Adobe Camera Raw (ACR). To create an HDR image in Photoshop choose [File > Automate > Merge to HDR Pro]. This opens a dialog box that allows you to pick the files to use for the HDR image (**Figure 18.1**). Once the files are selected, check the box at the bottom where it says Attempt to Automatically Align Source Images. This will reduce any ghosting that can occur if there was any movement in your scene between exposures. Select OK to combine the images.

After the files are selected and combined, Photoshop will open the Merge to HDR Pro window (**Figure 18.2**). This window has three parts: across the bottom are the individual images used to create the HDR image, in the middle is a preview of the final combined image, and on the right are the controls for adjusting the HDR image.

In the Mode drop-down menu you can select 32, 16, or 8 Bit. If you choose 32 Bit, you will see that you can Tone in ACR, which is great for creating realistic looking images. I will cover ACR a little later in this lesson, but for now it's just good to know you can get to it from the Merge to HDR Pro window. For the purposes of this lesson, uncheck the box that says Complete Toning in Adobe Camera Raw and then click on

OK at the bottom of the window to send the 32-bit file back to Photoshop. You can now save the 32-bit file in the PSD or Tiff format. This is your digital HDR negative from which you will create the final 16- or 8-bit files.

The next step is tone mapping and creating a 16-bit (or 8-bit) image. Select [Image > Mode > 16 Bit] (or 8 Bit), which will open the HDR Toning window (**Figure 2.27**). The controls in this window are the same as those in the Merge to HDR Pro window, but processing the file this way allows you to keep using the same 32-bit file over and over again so you can process it differently each time.

In the HDR Toning window you now have all of the controls you need to create your HDR file:

- **Preset:** Photoshop ships with a bunch of presets and I urge you to think of these just as a starting point. Once you create a look you really like, you can save it as a preset to use later. Click on the little gear icon next to the preset drop-down list to load or save a preset.
- **Edge Glow:** The edge glow settings reduce the halo effect that can show up in areas of contrast, which is one of the biggest issues in poorly converted HDR images. You want to reduce this effect as much as possible. The Radius control specifies the size of the areas of local brightness, while the Strength control determines how far apart the tonal values need to be before the pixels are no longer considered part of the same brightness area.

The Radius and Strength controls work together to adjust the overall look of the image. Start with the sliders all the way to the left and move them toward the right until you get the look you want. If you check the Edge Smoothness box below the Strength control, Photoshop will try to boost the detail in the image while at the same time preserving smoothness at the edges.

- **Tone and Detail:** This includes the three main controls that affect how the image will look: Gamma, Exposure, and Detail. The Gamma slider controls the contrast, from washed out (all the way to the left) to punchy (all the way to the right). The Exposure slider controls the overall brightness of the image. The Detail slider softens or sharpens the image and ranges from -100 on the far left to +300 on the far right.
- **Advanced:** These four controls are for fine-tuning the image. The Shadow slider allows you to lighten up the dark areas and recover details that might be lost in the dark shadows. The Highlight slider allows you to recover detail in the brightest parts of the image. The Vibrance slider allows you to control the saturation in a smart way by not oversaturating the parts of the image that are already saturated. The Saturation slider increases and decreases the overall saturation of the image.

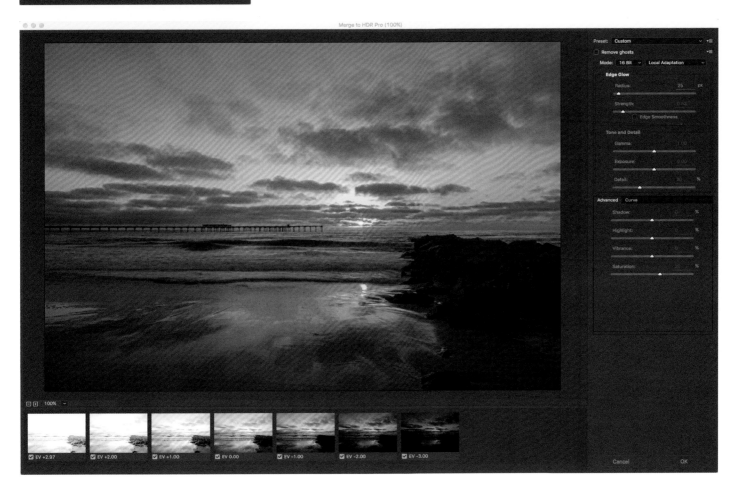

18.1 The Merge to HDR Pro dialog box in Adobe Photoshop CC.

18.2 The Merge to HDR Pro window in Adobe Photoshop CC. The files used to create the HDR image are shown at the bottom of the window and the tone mapping options are in the panel on the right.

- **Toning Curve and Histogram:** This shows you the current tone curve overlaid on the histogram for the image. You can adjust the tone curve by grabbing anywhere on the curve and moving it to the desired spot.

In **Figure 18.3** you can see both the HDR Toning panel and the final HDR image. Once you've made all of the adjustments, click OK to apply the adjustments to the image. At this point you can make any other image modifications and save the final image.

You can also use the Adobe Camera Raw module to process your HDR images. There are three ways to access the ACR module to edit the HDR images. The first option, as previously mentioned, is to navigate to [File > Automate > Merge to HDR Pro], load the image files and select the 32 Bit Mode, check the box that says Complete Toning in Adobe Camera Raw, and then click on Tone in ACR. This opens the full 32-bit image in Adobe Camera Raw.

The second way to open a 32-bit HDR file in Adobe Camera Raw is to use the ACR Filter. Earlier in this section I talked about saving a 32-bit PSD or Tiff file as a digital negative in Photoshop. You can now open this file without changing it to 16 or 8 Bit by navigating to [Filter > Camera Raw Filter].

Finally, you can also create an HDR file and edit it in ACR by opening the individual RAW images directly in Adobe Camera Raw. Click on the Filmstrip menu shown in **Figure 18.4**, click on Select All, and then select Merge to HDR from the same menu. Photoshop will create a new HDR file that you get to name and save, and it will automatically be opened in the Adobe Camera Raw window.

Once you have the image loaded into Adobe Camera Raw, you can adjust the image using the ACR tools. The default setting here creates a more realistic HDR image than the stand-alone HDR software because it just shows the 32-bit mapped image (**Figure 18.5**) before it is tone mapped to a 16-bit (or 8-bit) image.

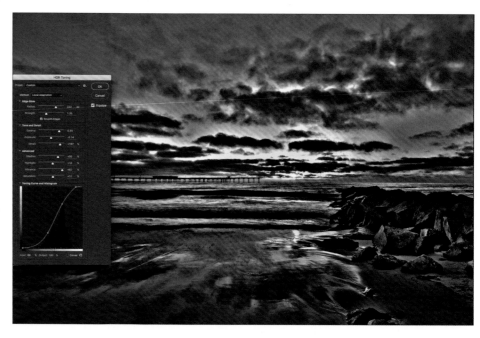

18.3 The HDR Toning panel and final tone-mapped HDR image in Adobe Photoshop.

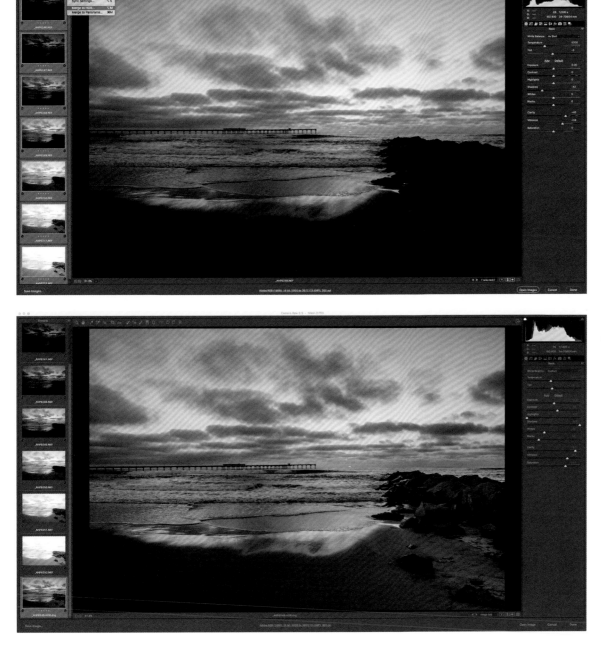

18.4 The Adobe Camera Raw interface with the Filmstrip menu showing both the Select All and Merge to HDR options.

18.5 The final HDR image edited in Adobe Camera Raw.

19. CREATING AN HDR IMAGE IN AURORA HDR PROFESSIONAL

THERE ARE A lot of different software packages that you can use to create stunning HDR images. The one I use more than any other is called Aurora HDR Professional, which is a joint project by Macphun and Trey Radcliff, one of the world's leading HDR photographers. There are two versions of the software, Aurora HDR and Aurora HDR Professional. I suggest using the professional version because it has more functionality than the basic version, including ghost reduction and Lightroom plug-in support, and it allows you to use an unlimited number of bracketed images.

To create an HDR image in Aurora HDR Professional, first launch the software and click on Load Images, and then navigate to the individual images you want to use. A window will open with the images you selected and checkboxes for Alignment, Ghosts Reduction, and Chromatic Aberration Reduction (**Figure 19.1**). One nice thing about this software is that it explains clearly what each of those checkboxes actually does.

When you check the Ghosts Reduction checkbox and click on Create HDR you will be presented with a Ghosts Reduction Options dialog that allows you to pick the reference image and the amount of ghost reduction you want to apply (**Figure 19.2**). Click on Create HDR to open the main editing window.

In the main editing window you can control each and every part of the image, creating a subtle, natural-looking image or a crazy, over-the-top, "crunchy" image. The choices are yours, and you get to make a lot of them. The Aurora HDR Professional workspace is divided into four sections (**Figure 2.32**). The preview window takes up most of the space and shows you the effects of the changes being made. Across the top of the screen you can see the usual controls for saving and exporting images and for adjusting the view of the preview window. On the right side are the image-editing controls and across the bottom are previews that show you exactly how the image will look when a particular preset is applied. The presets that ship with Aurora HDR Pro are all quite good and give you a fantastic starting point.

One of the really nice features of the software is that when you make adjustments using one of the image-editing controls, the name of that control changes color in the menu on the right. For example, in **Figure 19.3** you can see that I have made adjustments to all of the controls other than Tone Curve, Color Toning, and Layer just by looking at their color.

As you can see from the following list of editing options, there is a lot you can do in Aurora HDR Professional:

- **Tone Mapping:** You can control how the software maps the tone to the display and how much emphasis is placed on each image in the bracketed set.
- **Tone:** This panel controls the basic tones in the image, giving you control over the highlights, midtones, and shadows. You can also control the whites, blacks, and contrast in the image.
- **Structure:** This panel gives you control over how contrast is applied to edges in the image. Increasing the structure will make the image look more textured; decreasing the structure creates a less-textured look.
- **HDR Denoise:** When a set of bracketed images are combined into an HDR image, digital noise tends to get amplified along with the regular texture. These controls help to reduce noise in the image.
- **Image Radiance:** You can use these controls to smooth the color, colorize, and adjust the color temperature of the image.
- **Color:** These controls allow you to adjust the color, vibrance, color contrast, color temperature, and tint of the image.
- **Details:** This setting allows you to increase or decrease the details in the highlights, in the shadows, and in the entire image. There are also separate controls for small, medium, and large details.
- **Glow:** This gives the lighter tones in the image a soft glow.
- **Top & Bottom Lighting:** This control acts like a very intelligent gradual-density filter that allows you to split the image into two zones and then lighten and darken each zone separately. You can adjust the blend between the two sides and rotate and adjust the position of the effect. This is great for landscapes where you want the sky and the ground to be lit differently.

- **Tone Curve:** You can click anywhere on the tone curve to adjust the corresponding area of the image.
- **Color Filter:** There are six color filters that you can apply to the image. These are based on the filters you can put in front of the camera lens. Each color filter will brighten that color and darken the opposite color on the spectrum.
- **Color Toning:** This is where you can apply split toning, which is when you apply a tone to the highlight and/or shadow area of a black-and-white image. This control also allows you to tone basic black-and-white images.
- **Vignette:** Use this control to brighten or darken the edges of the frame. This helps to keep the viewer's attention on the middle of the frame.

- **Layer:** You can add different effects to the image using layers, which allows you to stack the effects on a single image. Each layer can have it's own effect and blend mode, and you can even add a custom texture to a layer. You can also mask out areas of a layer so the effect only impacts a part of the image.
- **Presets:** There are some amazing presets that come with Aurora HDR Pro, including a set designed by Trey Radcliff. This is the best place to start, and when you make a setting you like you can save it as a preset that will be included here.

19.1 The Aurora HDR Professional interface showing the images that will be used to create the HDR image and the Alignment, Ghosts Reduction, and Chromatic Aberration Reduction checkboxes.

19.2 The Ghosts Reduction Options window showing the reference image and the amount of ghost reduction.

19.3 The Aurora HDR Pro workspace.

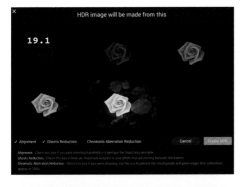

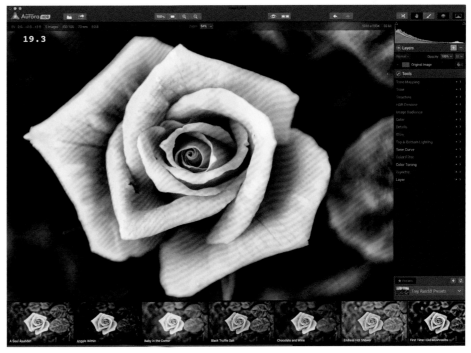

20. CREATING AN HDR IMAGE IN PHOTOMATIX PRO 5

ONE OF THE best pieces of HDR software available for both Windows and Mac users is Photomatix Pro 5 from HDRsoft. You can download a free trial of Photomatix from HDRsoft. com to see if it is something you want to buy. The only difference between the free version and the paid version is that the free version places a watermark over the images, so you can try it out but you can't create any final images.

Photomatix is a standalone program, but it can be launched from inside Adobe Lightroom by selecting the bracketed images and then exporting them using the Photomatix Pro preset. You can also open the application directly and load the images you want to combine by clicking on the Load Bracketed Photos button. The software can also create an HDR-looking photo from just one exposure, but since this is a book on multiple exposures, we'll stick to using a set of bracketed images. The software provides web tutorials that you can access from the button right on the home page of the application.

When you click on Load Bracketed Images you're presented with a window where you can browse the files on your computer and select the images you want to use, or you can drag and drop the images right onto the window. After you select the files and click OK, the Merge to HDR Options window opens (**Figure 20.1**). Here you can select whether you want Photomatix to align the source images (which is best for images that were shot without a tripod), show options to remove ghosts (which is best for subjects that moved during the exposures), reduce the noise (which minimizes noise when combining high ISO images), and reduce chromatic aberrations.

After you make your selections, click on the Align & Show Deghosting button to open the Deghosting window, where you can decide between Selective Deghosting and Automatic Deghosting. If you choose Automatic Deghosting, you will have to pick a base image and the amount of deghosting for the software to apply. If you pick Selective Deghosting, you get to select the areas where you want the deghosting to be applied, and leave other areas alone.

Once you have applied the deghosting, click OK and open the image in the main workspace. There are a lot of options here, but the easiest way to start processing your HDR image is to pick a preset from the right-hand column (**Figure 20.2**).

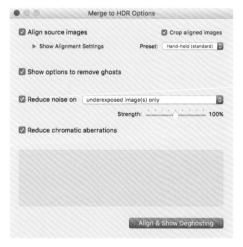

20.1 The Merge to HDR Option window in Photomatix.

20.2 The presets are a great starting point for processing your image. Each preset shows a preview of what it will do to the main image.

The main part of the workspace includes a preview of the image in the center of the screen with the image-editing controls on the left. The settings across the top of the screen allow you to control how the preview image is shown. The Preview control is very useful, as it allows you to switch back and forth between a preview of the adjusted image and the normal blended image.

On the left side of the screen, you can control the Tone Mapping or the Exposure Fusion of the image. When you select Tone Mapping, you determine how you will process the image by selecting one of three Methods: Details Enhancer, Contrast Optimizer, or Tone Compressor. Each option approaches editing in different ways and gives you a different set of controls (**Figure 20.3**):

- **Details Enhancer:** In this mode, you can control and adjust the following: Strength, Color Saturation, Tone Compression, Detail Contrast, and Lighting Adjustments. There is also a second panel with more options that allow you to control the Smooth Highlights, White and Black Points, Gamma, and Color Temperature. The third panel houses the advanced options, which include Micro-smoothing, Saturation for the highlights and shadows, Shadows Smoothness, and Shadows Clipping.
- **Contrast Optimizer:** This group of controls allows you to adjust Strength, Tone

Compression, Lighting Effect, the White and Black clipping points, Midtone, Color Saturation, and Color Temperature.

- **Tone Compressor:** This set controls the Brightness, Tonal Range Compression, Contrast Adaptation, White and Black clipping points, Color Saturation, and Color Temperature.

The second way to process the image is with the Exposure Fusion method (**Figure 20.4**). Both Exposure Fusion and Tone Mapping produce images by combining the bracketed photos into a single image, but Exposure Fusion combines the images in a simpler manner. It takes the highlight details from the underexposed image and the shadow details from the overexposed image and combines them with the normal image. You can adjust the Strength, Brightness, Local Contrast, White and Black clipping points, Midtone, and Color Saturation.

Both Exposure Fusion and Tone Mapping work well and can create some fantastic HDR images. After you adjust the appropriate settings and click Apply on the bottom left of the screen, the processed image opens along with the Finishing Touches panel (**Figure 20.5**). In this menu you can adjust Contrast, Color, and Sharpening. Once you have made the final tweaks to your image, click on Done and then save your finished file.

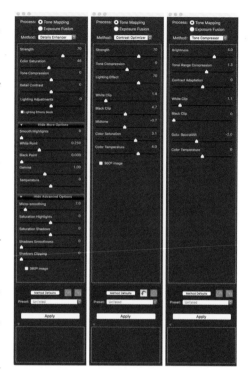

20.3 The Details Enhancer, Contrast Optimizer, and Tone Compressor adjustment panels (you only see one at a time).

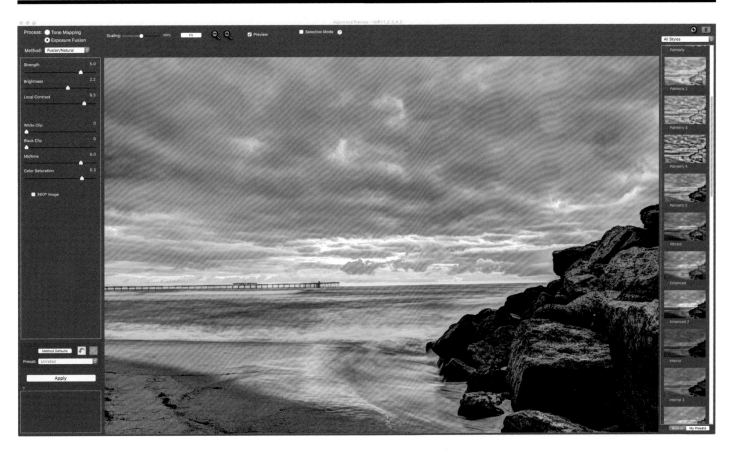

20.4 Exposure Fusion processes the image differently than the traditional tone mapping HDR method, but you still have the ability to adjust the settings.

20.5 The Finishing Touches menu allows you to fine-tune your HDR image even further.

21. NATURAL OR CRUNCHY?

THERE ARE CERTAIN things that polite people don't discuss because you know there will be an argument—subjects like religion, politics, and HDR photography. Some people love hyperrealistic colors and bold textures while others hate them and want photographs to look natural. I have divided the two styles of HDR photography into what I call natural and crunchy. The natural look is just that: images that don't look as if they were processed in an over-the-top method. The crunchy images are those that scream HDR processing. I personally think there is a time and place for both; it all depends on the subject and the client. I take a lot of photographs for a local sports and event center in San Diego and HDR processing works well for some of the subject matter, especially the building itself and the architectural details. The great part is that once I have the set of bracketed images, I can process them in a variety of ways and let the client pick out the version they want. So don't just decide you hate all HDR photography until you see what you can do with it.

The following photographs are all examples of the same images processed in multiple ways. This is just a small sampling of what you can do once you have the images to work with.

Sunset

These photographs of a sunset were created from a series of seven bracketed images ranging from –3 to +3 exposure. I used a Nikon D750 to capture NEF (Raw) files and processed them in Adobe Camera Raw. I then combined them into an HDR image in Aurora HDR Pro.

The sunset is a favorite subject of photographers everywhere. Sometimes the sky just doesn't give you a lot to work with. I photographed the following scene with a three-image bracket with a two-stop difference between each image. I processed the three images in Aurora HDR Pro to create both a subtle version (**Figure 21.3**) and a much more processed look (**Figure 21.4**). While I prefer the subtle version of the lifeguard tower shot (**Figure 21.1**), I prefer the brighter, processed image of this sunset (**Figure 21.4**).

21.1 This image was processed to give it a more natural-toned look.

21.2 This image was processed (or over-processed) to create a crunchy version of the sunset.

21.3 The beautiful California sunset processed to look more natural in this version.

21.4 The same scene processed with more crunch creates a more vivid and compelling image.

21.1

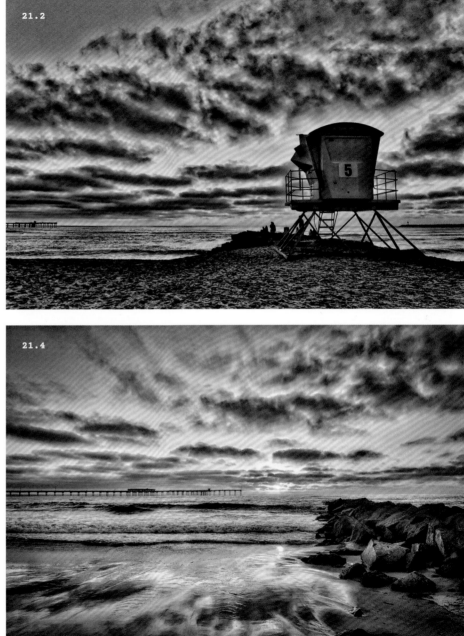

21.2

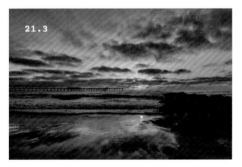

21.3

21.4

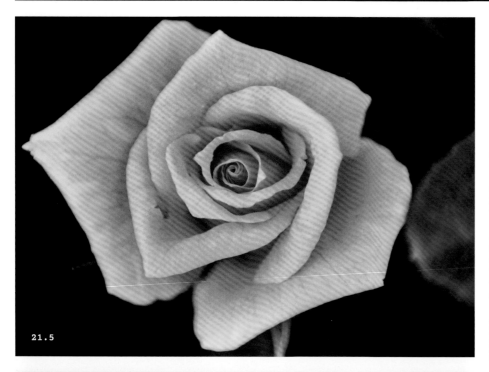

21.5

Roses

I went to the beach to photograph a scene for this book and when I was walking back to my car I came across these amazing rose bushes, so I stopped and shot them right there on the sidewalk. I bracketed the photos to make sure that I got the exposure right and then processed the images in Photoshop and Aurora HDR Pro.

21.5 The yellow rose was in deep shadows. By combining the bracketed images into an HDR image I was able to show more detail.

21.6 The pink rose was lit by direct sun, making it impossible to get detail in the bright and dark areas. When I processed this image I kept the look very bright, but you can still see detail in the shadows.

21.7 This image is less realistic and looks more like pop art. While this isn't exactly my style, someone might like it.

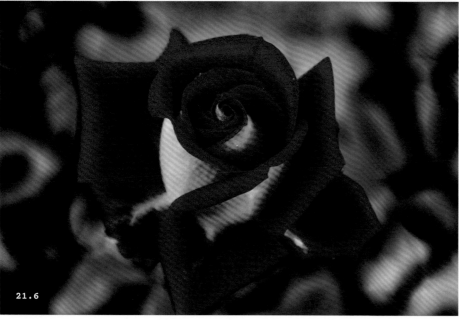

21.6

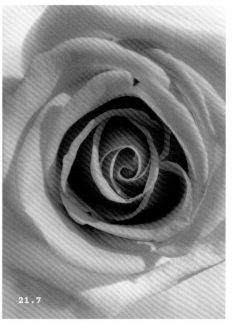

21.7

Basketball Court

This is a photo of the Valley View Casino Center in 2012 when the Los Angeles Lakers played the Sacramento Kings in a preseason game. I wanted to capture the whole venue before the doors opened so I used a 16mm fisheye lens and took a bracketed set of nine images with a one-stop difference between each exposure. I processed the combined HDR image in Adobe Photoshop to create **Figure 21.8**. I recently went back and processed the original nine images in Aurora HDR Pro and created **Figure 21.9**. I used the same original images but processed them in two very different ways to create two different images.

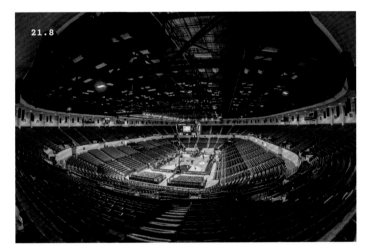

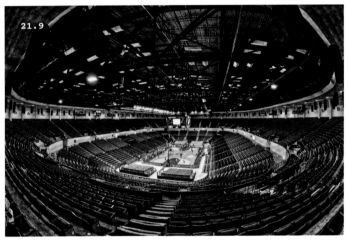

21.8 The original HDR image created in Adobe Photoshop is very natural-looking, especially compared to the image processed in Aurora HDR Pro.

21.9 Processing the nine images with Aurora HDR Pro created a more crunchy look, which is especially noticeable in the chair details.

22. ADD A BIT OF NORMAL BACK IN

THERE IS A technique used in HDR photography that I was introduced to by RC Concepcion that can make your images look more realistic. The basic idea is to overlay the normally exposed image (with the exposure of 0) on the HDR version, then selectively mask out parts of the normal image to let the HDR version show through.

This works really well for portraits in which you want the subject (especially their skin tone) to look normal, but want to maintain some of the HDR look in the surroundings.

First, create the full HDR version of the image (**Figure 22.1**). Then open the single image from the bracketed set with the exposure of 0—the one that is not over- or underexposed (**Figure 22.2**). In Photoshop, hold down the shift key and drag and drop the normally exposed image over the HDR image. This will center the new layer (normal exposure) over the existing layer (HDR image). Select both layers and navigate to [Edit > Auto-Align Layer] and click OK to make sure that the two images are properly aligned. Select the top layer and create a layer mask and fill it with black so that

you can see the HDR image through the normal exposure (**Figure 22.3**). Set the paintbrush to white and paint over the areas of the top layer that you want to see (**Figure 22.4**). You can

then adjust the opacity of the top layer to allow more or less of it to show (**Figure 22.5**). The final image is shown in **Figure 22.6**.

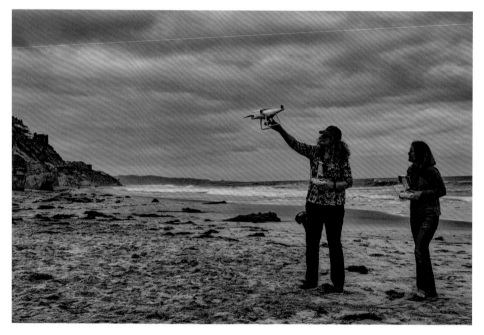

22.1 The full HDR image. As you can see, the skin tones look off.

22.2 This is the properly exposed image with 0 exposure. While the background isn't great, the people look normal.

22.3 In Photoshop you can see the two layers with the top layer (the normal exposure) masked out.

22.4 The HDR image shows through in the areas I painted black in the layer mask.

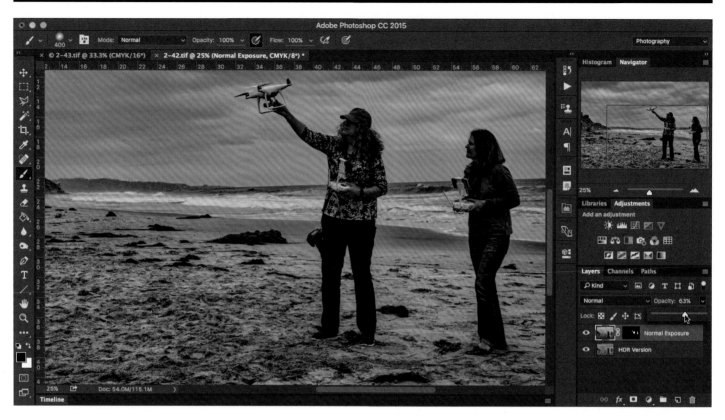

22.5 Adjusting the opacity of the top layer gives you control over how much of that layer is seen.

Share Your Best HDR Image!

Once you've captured your best HDR image, share it with the *Enthusiast's Guide* community! Follow @EnthusiastsGuides and post your image to Instagram with the hashtag *#EGHDR*. Don't forget that you can also search that same hashtag to view all the posts and be inspired by what others are shooting.

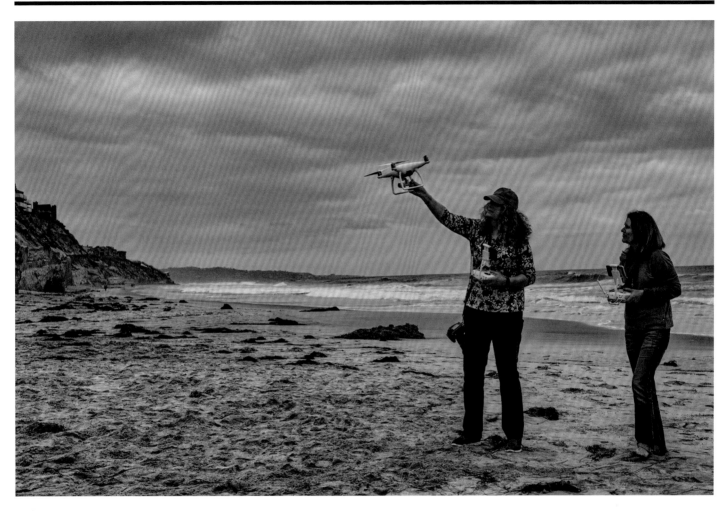

22.6 The final image with parts of the normal exposure used to tone down the HDR.

3

PHOTOGRAPHING PANORAMAS

CHAPTER 3

There are times when the scene you want to photograph doesn't quite fit into a single frame, even if you're using a lens with a wide angle of view. With digital photography and post-processing software, it is possible to take multiple digital photos and easily stitch them together into a single panorama. In this chapter I discuss the best ways to create the individual images so that the software can create the final panoramic photograph. This includes how many images to use, the amount of overlap required to stitch them together, the best exposure settings to use, and the benefits and drawbacks of shooting handheld or with a tripod. While Adobe Photoshop is the software of choice for many photographers, including me, there are also many other options out there for stitching panoramas, from free software online to programs like Kolor's Autopano. For the lessons on stitching in this chapter, I use Adobe Photoshop's Photomerge.

23. PANORAMA BASICS

BEFORE WE GET to actually taking the images used to build a panorama, I'd like to share a very important tip that I learned from Scott Kelby at a conference years ago. It's such a great tip that I have used it ever since. When you shoot images for a panorama you need to mark the first and last frame of the pano so that you can find the files easily when you're ready to work with them on your computer. This might seem unnecessary, but many times when you're looking at your images after a shoot it can be really difficult to figure out whether you just took two shots of the same scene or you intended to combine the shots into a two-image panorama. An easy way to mark the start and end of a pano set is to take a photo of one finger before you shoot the first frame of the pano and a photo of two fingers after you shoot the final frame of the

pano. When you are looking at your images in Bridge or Lightroom later on, you can easily see where the pano starts and where it ends. In **Figure 23.1**, you can see that I used this method to keep track of the images I shot for a panorama in Arizona.

The next thing to decide when shooting images for a panorama is whether to use a landscape or portrait orientation. When you look out at a vista that you want to capture in a panoramic image, your natural inclination will likely be to take a series of images in landscape orientation. However, if you shoot a series of portrait-oriented images and combine them into a landscape panorama, you'll actually be able to create a panoramic image with more detail, especially above and below the subject. This leaves you with more area that can be cropped

in different ways, allowing for greater flexibility in composition.

Let's look at an example of the same scene shot in both landscape and portrait orientation and the effect the orientation has on the final panorama. In **Figure 23.2** you can see the nine landscape images I used to create the panorama shown in **Figure 23.3**, which has a resolution of 27053 × 3147 pixels, or is just over 90″ wide by 10.5″ high at 300 dpi.

In **Figure 23.4** you can see the portrait-oriented photographs of the same scene. This time I combined 13 frames to create the panorama shown in **Figure 23.5**, which has a resolution of 22129 × 5196 pixels, or is over 73″ wide by 17″ high at 300 dpi.

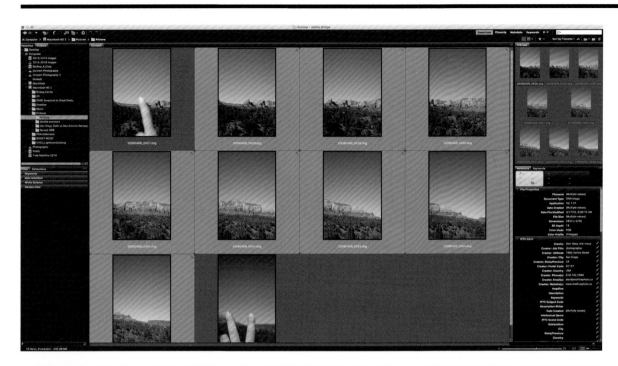

23.1 The Bridge interface with the start and end of my image set marked with the one finger, two finger method.

23.2 I combined nine of these landscape-oriented images to create my final panorama.

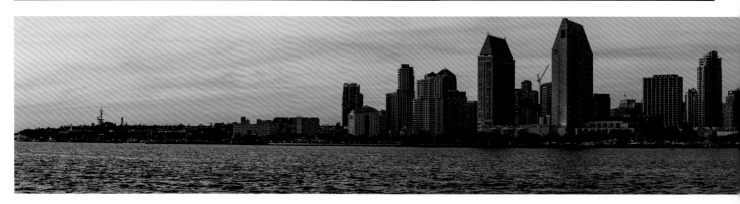

23.3 The final panorama created from nine landscape-oriented files.

Share Your Best Panoramic Image!

Once you've captured your best panoramic image, share it with the *Enthusiast's Guide* community! Follow @EnthusiastsGuides and post your image to Instagram with the hashtag *#EGPanorama.* Don't forget that you can also search that same hashtag to view all the posts and be inspired by what others are shooting.

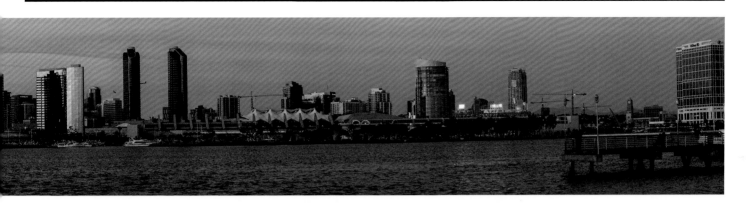

23.4 I combined 13 of these portrait-oriented images to create my final panorama.

23.5 The final panorama created from 13 portrait-oriented files. This image includes more of the sky above the buildings.

24. HOW MANY EXPOSURES
DO YOU NEED?

YOU CAN CREATE a panoramic image from as few as two images, or you can use many more. The actual number of frames you need depends on two factors: the size of the subject you're photographing and the orientation of the exposures used.

The perfect number of exposures is when there are enough to create a panorama in the detail that you want. I know that sounds vague, but every photographer has different needs. If you are planning on making a very big print of the panorama you will need a lot of images to increase the resolution of the final image. For this type of panorama, I suggest using a camera orientation that is opposite from the final image orientation. If you want to create a horizontal panorama, for example, I suggest stitching together a bunch of vertical images. I used nine vertical images to create **Figure 24.1**.

If you are creating a vertical panoramic image, I suggest stitching together a series of horizontal images. I used five horizontal images to create **Figure 24.2**.

The downside to this method (i.e., combining

24.1

vertical images to create horizontal panoramas, and vice versa) is that it is more time-consuming and requires more individual frames, more storage space, and longer processing times than using horizontal images for horizontal panoramas and vertical images for vertical panoramas. If you are planning on making a small print or only want to use the image online, the resolution can be much lower and you can get away with fewer images. In the end, it is up to you to decide how many shots you need for your panoramic image.

On occasion I will shoot a set of just a few images of a scene so I can create a small print of the panorama, and then I'll shoot it again and take many more images to make sure I have enough information if I need a higher resolution for a big print.

24.1 This panorama of the Edgewater Hotel and the Colorado Belle consists of nine vertical images.
ISO 200; 1/3200 sec.; f/4.5; 45mm

24.2 This panorama of the Cabrillo monument statue is made up of five horizontal images.
ISO 200; 1/640 sec.; f/7.1; 62mm

25. MAKE SURE
YOUR IMAGES OVERLAP

THE FIRST TIME I used Adobe Photoshop to create a panoramic image, I was stunned by how well the software was able to line up the images and seamlessly blend them together into a single photo. While the software does an amazing job, you can make it easier by giving the program enough information to match up the images.

The goal is to capture enough information for the software to be able to match the objects in the frame, but not so much that it becomes redundant. According to Adobe, your images should overlap by somewhere between 40%

and 70%. However, I've found that a 30%–40% overlap works really well. **Figures 25.1** and **25.2** show two images that I used to create a panorama; you can see where they overlap. In **Figure 25.3** the same two images are joined together.

Many cameras have a grid you can see through the viewfinder. This is a great tool to use when you're determining overlap in your scene. For example, if you're shooting a scene from left to right, move your camera so that the portion of your scene that was aligned with the right-hand gridline in the first shot is aligned with

the left-hand gridline in the second shot. You can see the viewfinder grid of the Nikon D750 overlaid on the scene in **Figures 25.4** and **25.5**. When I move the camera based on the grid, the overlap is about 35%.

When you create the full panorama, there is not a perfectly straight line where the images overlap. Photoshop has the ability to combine the images and join them together to create a seamless image. **Figure 25.6** shows the masks used by Photoshop to create the final panorama (**Figure 25.7**).

25.1 The red area is the part where this image overlaps with the next image.

25.2 The red area is where this image overlaps with the previous image.

25.3 I combined Figures 25.1 and 25.2 to create this panorama. The area where the two images overlap is right in the middle.

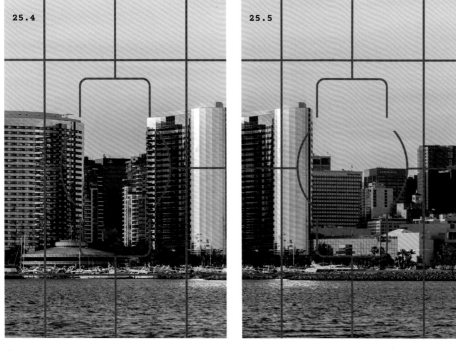

25.4 I used the viewfinder grid on my Nikon D750 to determine where to start and stop the overlap.

25.5 The portion of the scene that was aligned with the right-hand gridline in the previous shot is now aligned with the left-hand gridline.

25.6 Photoshop used layer masks to seamlessly combine the frames into a panoramic photograph.

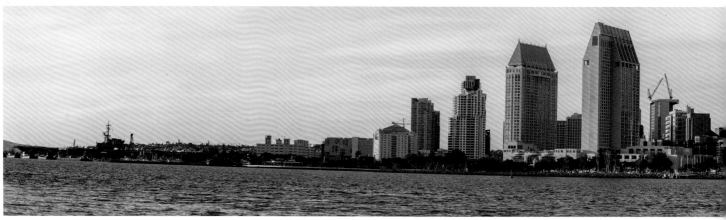

25.6

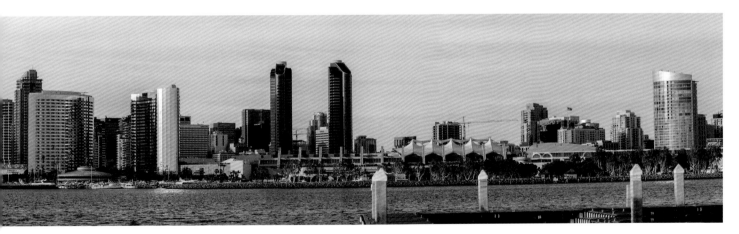

25.7 The final panoramic photo made up of multiple images that all overlap by about 35%.

26. KEEP YOUR EXPOSURE SETTINGS CONSISTENT

TO CREATE A seamless panoramic image, the exposure of each image you use needs to be the same, and that means you need to shoot in Manual mode. It is important to keep the shutter speed and aperture consistent for each shot that you plan to use in a panorama. If the exposures are different, Photoshop will try to blend the images together but it can leave odd-looking stripes in your image. In **Figure 26.1** I overlaid two images that I shot with slightly different exposure settings and you can clearly see the difference between the two. If the aperture changes between images, the depth of field will also change. This makes it much more difficult for the software to stitch the images together and the final panorama will not look right. If the shutter speed varies, the sharpness of the images will be different. This again makes it more difficult for the software to combine the images and the final panorama will look wrong (**Figure 26.2**). Even if the exposure changes just a little bit between the images, it will cause the final panorama to have areas that are darker or lighter than surrounding areas. This might not be noticeable in the individual frames, but will be noticeable in the final image.

Thankfully, there is a really easy way to get the proper exposure settings every time:

1 Set the camera to Aperture Priority mode.
2 Pick an aperture based on the depth of field you want in the final panorama.
3 Aim the camera at the most important part of the scene (usually right in the middle).
4 Press the shutter release button halfway down. This will cause the camera to pick a shutter speed based on the aperture and the amount of light in the scene.
5 Take note of the shutter speed picked by the camera (**Figure 26.3**).
6 Change the exposure mode to Manual.
7 Set your camera to the aperture from step 2 and the shutter speed from step 5.

Each image in the series will now have the same exposure, and the final combined image will be properly exposed (**Figure 26.4**).

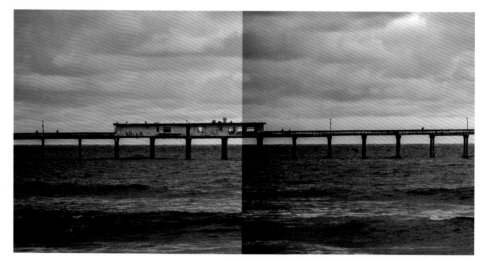

26.1 The images used to create this panorama were shot with different exposure settings, and it's clear that the two images don't match up.

26.2 The images used to create this panorama were shot with different shutter speeds and apertures. The background on the right side of the image is sharp but the background on the left side is not.

26.3 In Aperture Priority mode, your camera will set the shutter speed based on the aperture you've selected. For example, I selected an aperture of f/7.1 and the camera set the shutter speed to 1/640 second.

26.4 The images used to create this panorama were all shot with the same shutter speed and aperture. This allowed for smooth transitions between the images.

27. WATCH YOUR FOCUS
AND FOCAL LENGTH

IT IS EQUALLY important to maintain consistent focus in all of the images that will make up a panorama. Your point of focus needs to be the same distance from the camera for each shot, especially if you are shooting with a shallow depth of field and your focus is on something close. Look at **Figure 27.1** to see what happens when the software tries to stitch together a series of images in which the focus is vastly different for each image.

The key here is to make sure that you are using the right focus mode and that there is nothing in the scene that is going to pull the focus off of the main subject. Most cameras have a variety of focus modes that use anywhere from one autofocus point to all of the autofocus points. The problem with using all of the autofocus points is that the camera will try to focus on whatever is closest to it for each shot, and that might not be the subject of the panorama.

When you photograph an area where there is something between the subject and the camera the focus could easily shift. It's important to pay attention to what the camera is actually focusing on, and if necessary, switch to a single autofocus point and move that point around the frame to keep the focus on the subject in each shot.

When I shot the images for the panorama shown in **Figure 27.2**, I made sure the focus point was always on the pier and not on any of the people in front of me. As you can see, the pier is in sharp focus and the people are not.

You also need to use the same focal length for each image you shoot for a panorama. If you're using a zoom lens, make sure the focal length doesn't change when you move the camera between each shot. The focal length determines how much of the scene in front of the camera is recorded in each photo. If you change focal lengths even slightly, the objects in the photos will not align properly when Photoshop tries to stitch the frames together. When I shot the images for **Figure 27.3** I used the same focal length for each frame, so the areas that overlap are the same. This made it easy for Photoshop to combine the two images. For **Figure 27.4** I changed the focal length between the two images and the areas that overlap do not match, which made it very difficult for Photoshop to stitch them together.

27.1 While Photoshop does a great job of trying to stich together images with different points of focus, the final image still has problems.

27.2 Make sure that the focus is on the same subject in all of the images. In this case, I focused on the pier and not the people.

27.3 When you use the same focal length for each image in a panorama, the images match up easily.

27.4 Even if there is a slight change in the focal length between images, the objects in the frames don't line up.

28. YOU CAN SHOOT PANORAMAS HANDHELD

I'VE SHOT MOST of my panoramic photos without a tripod. Yes, you read that correctly—I didn't use a tripod for many of my panoramic photos and I have a really good reason. You don't actually need a tripod as long as you pay attention to the overlap and use a shutter speed high enough to freeze any motion in the image, including any motion from camera shake. That and I didn't have a tripod with me.

Camera shake is the small movements that happen when you handhold the camera. This becomes especially problematic at longer focal lengths. So how fast of a shutter speed do you need to use to freeze the action and negate any camera shake? The standard rule in photography is that the minimum shutter speed should be the inverse of the focal length. So if you are shooting at 200mm, you need to use a shutter speed of 1/200 second or faster. If you are really good at holding the camera steady, you can use a slower shutter speed and still get sharp images. But when it comes to panoramas, all of the images need to be sharp, not just a few.

The key to holding the camera really steady is to create a solid base and support the camera from below. I support the lens from below with my left hand and tuck my left elbow into my side. This allows me to put the camera against my left shoulder and hold it there with my right hand (**Figure 28.1**).

Camera manufacturers have developed technology that makes it easier to get sharp images at slower shutter speeds. Nikon calls this feature Vibration Reduction (**Figure 28.2**), Canon goes with Image Stabilization, and Sony calls it SteadyShot. For Nikon and Canon users, the technology is built into the individual lenses and can be used with all of the camera bodies. Sony technology is built into the camera body itself. You can turn this feature on or off as needed. When handholding the camera for panoramas, turn on Vibration Reduction (or Image Stabilization or SteadyShot). This feature usually works really well.

Once you are holding the camera in a steady position, the idea is to just rotate from left to right (or right to left), taking a series of images as you move the camera. Try to keep the camera level—a tilt of more than a few degrees can cause issues when you stitch the photos together. I use the viewfinder grid and try to keep one of the lines on the horizon (**Figure 28.3**).

When you are handholding the camera, pause between each shot to make sure the horizon is straight and there is an overlap of 30% or more. Rushing between shots is the easiest way to end up with images that are titled or out of alignment. You also want to give the Vibration Reduction (or Image Stabilization or SteadyShot) time to work. It is activated when the shutter release button is pressed, so it doesn't need a lot of time, but a little pause can help.

When shooting other types of images (not panoramas), my cameras are usually set to continuous release mode, which means the camera keeps taking photos as long as the shutter release button is pressed down. This is great for shooting sports, concerts, and HDR images, but it doesn't work well when you're photographing images for a panorama. For panoramas, set your camera to single frame release mode so that the camera takes a single shot each time the shutter release button is pressed (**Figure 28.4**).

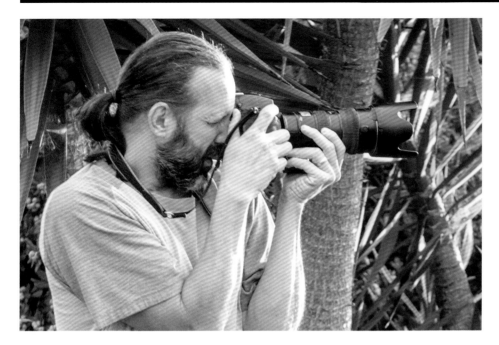

28.1 Holding the camera steady by setting up a solid base allows you to capture sharp images without a tripod.

28.2 The Vibration Reduction switch on my Nikon 70-20mm f/2.8 lens.

28.3 The grid overlay in the Canon 5D Mark IV.

28.4 The mode dial on my Nikon D750 set to single frame release mode (S).

29. USING A TRIPOD FOR PANORAMAS

THERE IS NO doubt that a tripod will help your photography. Using a tripod allows you to keep your camera rock steady during the photo-making process, making it much easier to capture sharp images. When you're taking panoramic photos it's important to keep the camera steady for each image; however, you also need to move the camera between shots. There are specialized tripod heads for panoramic photography that allow you to capture a series of images without parallax distortion (when objects in the foreground seem to change position from one image to the next).

A standard tripod head is designed to hold and rotate a camera around the tripod mounting hole in the bottom of the camera. This tripod mounting hole is usually aligned with the center of the lens, but not always. When you're taking images for a panorama, the camera needs to rotate around the nodal point (also called the optical center or entrance pupil). When the camera is rotated around the nodal point, the resulting images do not have any parallax distortion. Using a specialized tripod head allows you to rotate the camera properly. This can be really useful for creating 360-degree photos and multi-row panoramas.

You can see parallax distortion in **Figures 29.1** and **29.2**. Both of these photos were taken at roughly the same spot, but as you can see, the smallest change in angle has quite a large effect on the how items in the foreground

(in this case, the flag) interact with the background. In **Figure 29.1**, the flag is positioned between two vertical lines on the memorial, but in **Figure 29.2**, it has moved and is directly on top of one of the vertical lines on the memorial. This is caused by the camera moving slightly between images.

While a specialized tripod head is useful, you can also use your regular tripod head and let Adobe Photoshop try to stitch the images together and adjust the results to create a

seamless panorama. The best way to do this is to try to keep the camera centered on the tripod and rotate the camera from left to right. I use an L plate so that I can center the camera on the tripod in both portrait and landscape orientation. You can see my Nikon D4 with the L plate mounted on the tripod in both orientations (**Figure 29.3**).

If you shoot a lot of panoramas and want to purchase a tripod head designed for this purpose, the Panosaurus is a good option. It

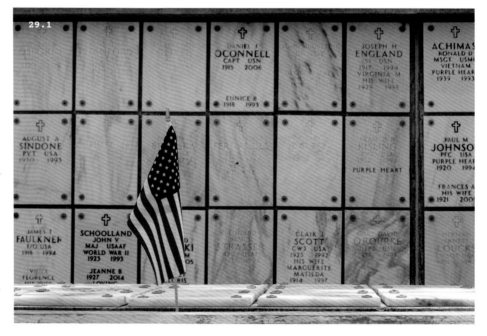

29.1

supports cameras up to ten pounds and costs about $100. This tripod head is designed to support a camera and lens over the nodal point and it has color-coded markings on the base so you can measure the rotation of the camera in degrees.

Another option is the Manfrotto MH057A5 head, which allows you to shoot sequential frames around the single axis in either portrait or landscape orientation.

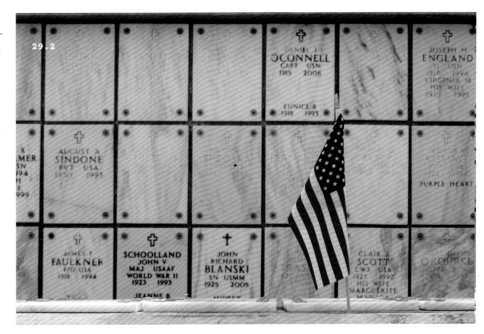

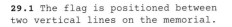

29.1 The flag is positioned between two vertical lines on the memorial.

29.2 The flag now appears to be in a different spot.

29.3 Using an L plate allows me to position my camera both vertically and horizontally with the center of the lens in the middle of the tripod head.

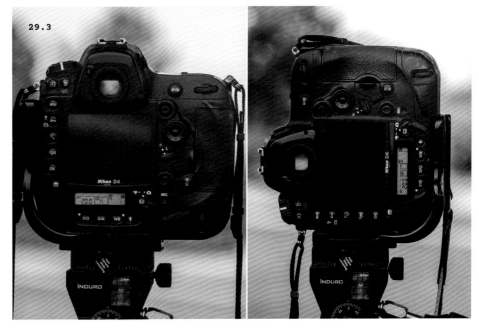

30. HORIZONTAL VERSUS VERTICAL PANORAMAS

WHEN WE THINK of panoramas we usually think of wide vistas, but panoramas can also be vertical. With more and more photographers using drones, creating vertical panoramas has become increasingly popular because it is now much easier to get a unique perspective on any scene. You can also take great vertical panoramas from the ground with your DSLR (**Figure 30.1**).

To capture this type of image you simply have to work from bottom to top instead of left to right. You will want to leave a lot of overlap so that the software can combine the images. If you use a series of landscape images with an overlap of more than 30% you will end up with a lot of images. You can see a set of images I used to create a vertical panorama in **Figure 30.2**. The overlap area for each image is shown in **Figure 30.3**.

The biggest issue that you will face is when photographing a building as a vertical panorama. When you photograph a building by pointing the camera upward, the vertical lines on the sides of the building appear to move in toward each other. You can see this in **Figure 30.4** where the building seems to be narrower at the top than it is at the bottom.

The only way to really fix this is to shoot from a higher vantage point so that the front of the lens is parallel to the building. Obviously, this isn't always possible, so Photoshop comes to the rescue one more time. First, stitch your images together in Photoshop to create the vertical panorama. Then you can use the Adaptive Wide Angle filter to adjust the vertical lines in the image. In **Figure 30.5** you can see an original panorama with converging lines. I adjusted the image with the Adaptive Wide Angle filter (**Figure 30.6**), and you can see the final corrected image in **Figure 30.7**.

30.1 Tall buildings are great subjects for vertical panoramas.

30.2 A set of images I used to create a vertical panorama.

30.3 The overlap showing how the images will be stitched together.

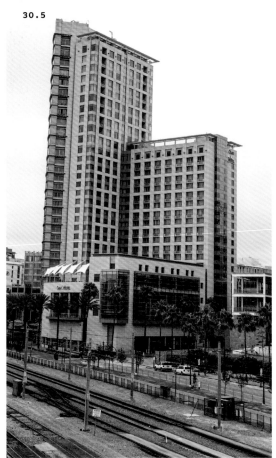

30.4 Shooting from the ground and aiming the camera upward can make the subjects look as though they are leaning.

30.5 The building looks like it's leaning to the right.

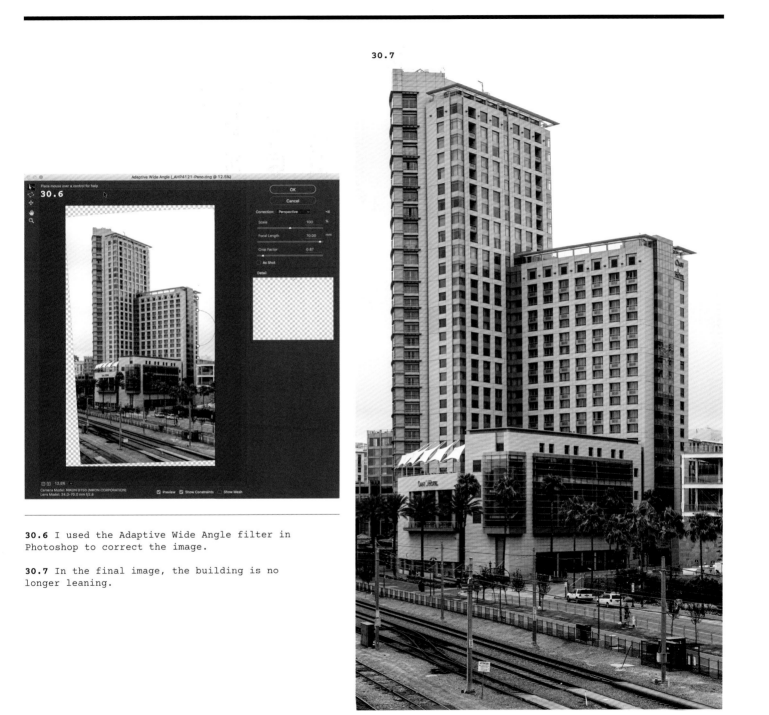

30.6 I used the Adaptive Wide Angle filter in Photoshop to correct the image.

30.7 In the final image, the building is no longer leaning.

31. USING ADOBE PHOTOSHOP PHOTOMERGE

I USE ADOBE Photoshop and Adobe Lightroom to create my panoramic photos. The module that creates the panoramas is called Photomerge and it can be accessed from Adobe Photoshop, Lightroom, Camera Raw, and Bridge.

In Photoshop, click on [File > Automate > Photomerge] to open the Photomerge module (**Figure 31.1**). In Lightroom you can select the images you want to use to create the panorama and click on [Photo > Photomerge > Panorama]. If you use Bridge to view your images, you can select the images you want to stich together and then select [Tools > Photoshop > Photomerge] (**Figure 31.2**), or you can open the files in Adobe Camera Raw. In Adobe Camera Raw, click on the Filmstrip menu and choose Select All, then choose Merge to Panorama from the same menu (**Figure 31.3**).

There are six layout options in the Photomerge menu (**Figure 31.4**):

- **Auto:** This gives Photoshop control over which layout option to use—Perspective, Cylindrical, or Spherical—depending on which one creates a better image.
- **Perspective:** This uses the middle image as the reference image and builds the panorama around that. It can cause a bow-tie effect, as seen in **Figure 31.5**.
- **Cylindrical:** This reduces the bow-tie distortion that can happen with the Perspective mode and is best suited for very wide panoramas.

- **Spherical:** This tries to align and transform the image as if it were the inside of a sphere. It is used for 360-degree panoramas.
- **Collage:** This aligns the source images (layers) and matches up the overlapping areas. If necessary, it also transforms layers to line them up properly.
- **Reposition:** This aligns the source images and matches up the overlapping content but does not stretch or skew any of the images.

At the bottom of the Photomerge menu, you can select whether you want Photoshop to perform any of the following tasks by placing checkmarks in the corresponding boxes:

- **Blend Images Together:** Photoshop finds the optimal border between the images and creates a custom seam. If the setting is turned off, a simple rectangular blend is performed. Turn this off if you want to make a custom seam between the images or if you are making a panoramic collage, which we'll discuss later in this chapter.
- **Vignette Removal:** The software tries to remove or correct any dark edges caused by lens vignetting. I usually have this feature turned on.
- **Geometric Distortion Correction:** Photoshop tries to compensate for pincushion, fisheye, and barrel distortion. I usually turn this setting on.
- **Content Aware Fill Transparent Areas:** Photoshop will try to fill in any transparent areas in the image with content from nearby

areas. Photoshop does an amazing job of filling in the areas with content that matches, creating a seamless image.

After you have made your selections, click OK and Photoshop will build the panorama.

31.1 Accessing the Photomerge module from Adobe Photoshop.

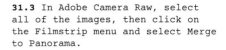

31.2 Accessing the Photomerge module from Adobe Bridge.

31.3 In Adobe Camera Raw, select all of the images, then click on the Filmstrip menu and select Merge to Panorama.

31.4 The Photomerge menu with the six layout options on the left.

31.5 The Perspective layout option can cause a bow-tie effect.

32. 360-DEGREE PANORAMAS

IMAGINE SHOOTING A panorama and instead of stopping when you've covered about 180 degrees you keep going in a full circle, creating a 360-degree panorama (**Figure 32.1**). It's best to use a super wide or fisheye lens to shoot this type of panorama because these lenses cover a lot of area, which means you need fewer photos to cover the full 360 degrees. In **Figure 32.2** you can see the images I used to create the 360-degree panorama shown in **Figure 32.3**.

When shooting a 360-degree panorama, it's easy to get dizzy since you're turning around in a full circle while staring through a viewfinder and trying to keep the images lined up. Using a tripod can help you to keep the camera steady and make sure your images are aligned properly.

Often, 360-degree panoramas are used to create virtual tours. To create the virtual reality (VR) environment, you will need to take all of the regular photos for the panorama as well as a photo of the ground and one of the sky.

You can create a 360-degree panorama with PTGui (www.ptgui.com).

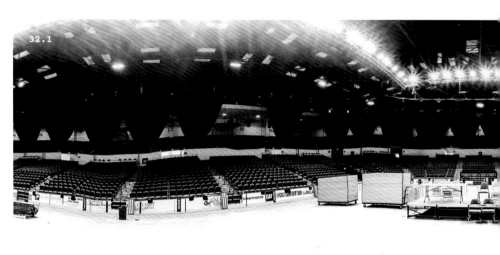

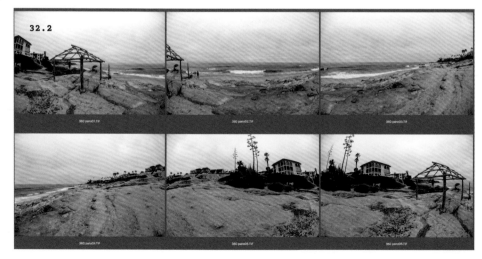

32.1 A 360-degree panorama shows everything in the scene.
ISO 800; 1/125 sec.; f/5.6; 16mm

32.2 The images used for the 360-degree panorama.

32.3 The full 360-degree panorama created with PTGui.

32.3

33. CREATING PANORAMIC COLLAGES

ALL OF THE types of panoramas we've discussed so far are created by combining multiple images into a seamless image. In a panoramic collage, you can see the individual images that make up the panorama. This type of image is really easy to make because you don't have to blend the layers in Photoshop. Once you've completed the simple process of combining the images, there are some cool things you can do to take this type of image to the next level.

After you shoot the images for your panorama and upload them to your computer (**Figure 33.1**), follow these steps to create the basic panoramic collage:

1 Open Photoshop and click [File > Automate > Photomerge].
2 Select the files you want to use and make sure to uncheck the Blend Images Together option at the bottom of the Photomerge dialog.
3 Select the Collage layout option.
4 Click OK and let Photoshop do it's thing.

Each image will be placed in the correct location in the panoramic collage, but there are no layer masks, so each image will look like it was placed on top of the images below it. You can see the resulting layers in **Figure 33.2**.

Photoshop assembles the set of images from one side to the other, stacking each image on top of the previous one. This looks fine but isn't quite what we want, so the next step is to adjust the order of the images. I like to start in the middle and then move outward (**Figure 33.3**).

We're getting closer to the final collage, but I still want it to look like the separate images are laying on top of each other. To create this look, I need to add a stroke or border around each image and a slight drop shadow. Once I have the drop shadow and stroke how I want them on the center image (**Figures 33.4** and **33.5**), I copy and paste the layer styles to all the layers (**Figure 33.6**). Then I can tweak each individual image to get the look I want. I rotate some of the images slightly and the alignment looks more natural. The final panoramic collage is shown in **Figure 33.7**.

As I mentioned, you can also take your panoramic collages to the next level and make some really wild pieces of art. One technique is to confuse the Photomerge algorithm by shooting your source images in a disorderly fashion.

Take a series of images of the same object, but instead of trying to line up a smooth vista, shoot with a telephoto lens and just photograph pieces of the subject that overlap. In **Figure 33.8** you can see a set of images I used for this type of collage and how disorderly they are. I photographed the building with a 200mm focal length and didn't keep the camera straight. Each photo is just a small portion of the overall scene.

Use the following steps to blend the images together:

1 Open Photoshop and click [File > Automate > Photomerge].
2 Select the files you want to use and make sure to uncheck the Blend Images Together option at the bottom of the Photomerge dialog.
3 Select the Collage layout option.
4 Click OK and let Photoshop do it's thing.

The resulting image is pretty cool (**Figure 33.9**), and now you can adjust each layer and add a drop shadow as before. This technique can be used to create both really abstract images and images that are more normal-looking—it all depends on how straight you keep the camera when you're shooting.

_AHP6799.NEF _AHP6800.NEF _AHP6801.NEF _AHP6802.NEF

_AHP6803.NEF _AHP6804.NEF _AHP6805.NEF _AHP6806.NEF

33.1 The original images I used to create a panoramic collage.

33.2 The layers in Photoshop.

33.3 I like to reorder the layers starting with the center image, which is now the top layer.

33.4 The Layer Style panel showing the settings for the stroke.

33.5 The Layer Style panel showing the settings for the drop shadow.

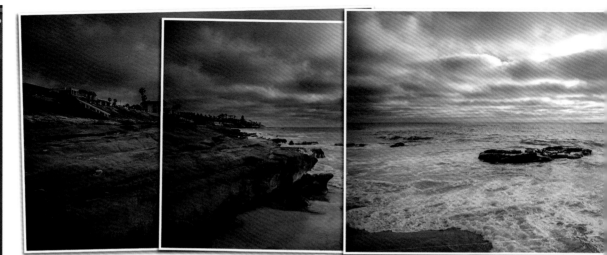

33.7 The final panoramic collage.

33.6 All of the layers now have the same stroke and drop shadow.

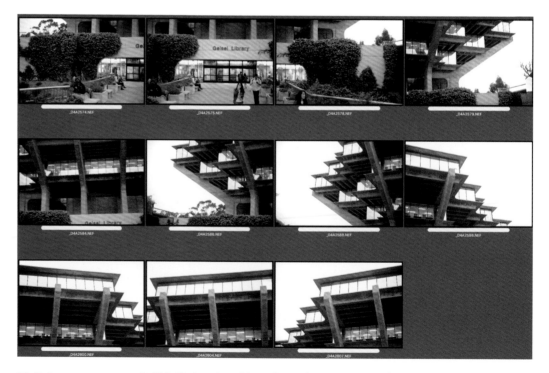

33.8 As you can see, I didn't try to align these images perfectly.

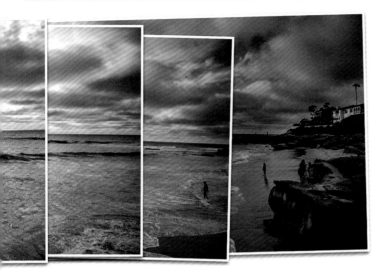

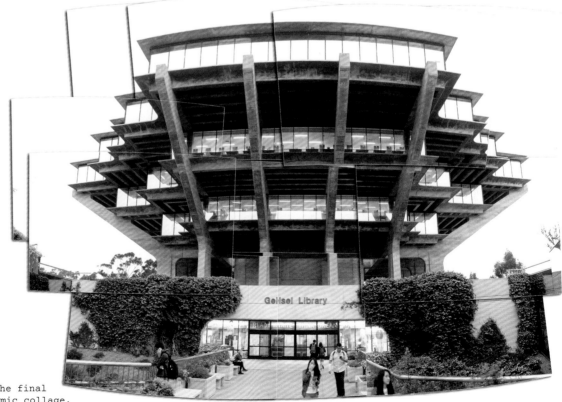

33.9 The final
panoramic collage.

34. CREATING HDR PANORAMAS

YOU CAN COMBINE the HDR techniques from chapter 2 with the panoramic techniques in this chapter to create HDR panoramas. For this technique to work properly, you need to use a tripod so that the camera doesn't move while you shoot the multiple exposures for the HDR images.

Begin by shooting a bracketed set of images for each frame you plan to use to create the panorama. There are a few things that you need to keep in mind from the start:

- The base exposure needs to be the same for each set of images.
- The HDR settings need to be the same for each of the final images used in the panorama.

After you have processed all of the bracketed sets, you end up with a set of HDR images that you can merge into a panorama. In **Figure 34.1** you can see the original bracketed images I shot—there are a lot of them. In **Figure 34.2** you can see the HDR images I created, which all have the exact same HDR setting. The HDR panorama shown in **Figure 34.3** contains four HDR photos that were each created from

three-bracket images with exposures of -2, 0, and +2.

This technique is really great for producing unique images because you can create any HDR look you want when you process the source

images, and you can keep combining them into new panoramas. Check out **Figures 34.4** and **34.5**, which were both created from the same bracketed source images but were processed in very different ways.

34.1 The full set of bracketed images I used to create the HDR photographs that make up the HDR panorama.

34.2 The HDR photos I used to create the final panorama.

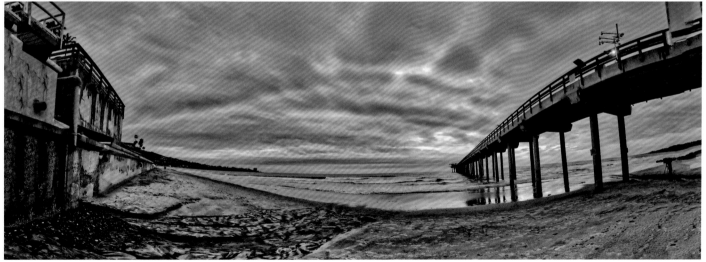

34.3 The final HDR panorama after I cropped it in Photoshop.

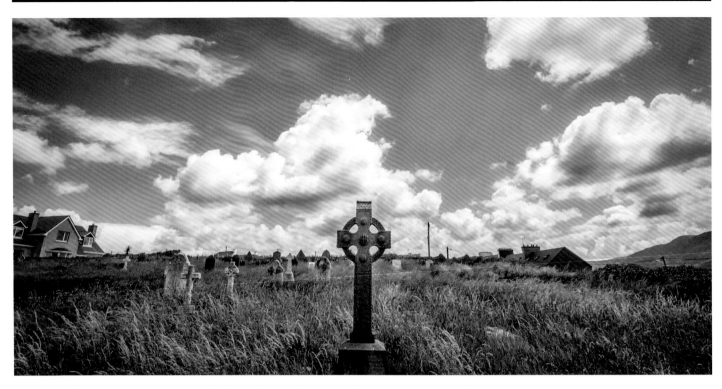

34.4 In this version I desaturated the colors and increased the contrast in the sky.

34.5 In this version I created a more saturated and dreamy look by smoothing out the edges, especially in the clouds.

35. CREATING GIGAPIXEL PANORAMAS

A GIGAPIXEL PANORAMA is an image created from hundreds or even thousands of images stitched together into a single panorama with amazingly high resolution. This really is taking panoramic photography to the next level. To create this type of image, you need a special device that can move the camera between each exposure so that each part of the scene is photographed properly, and you need the software that will stitch all of the images together.

The first piece of equipment you need is the GigaPan Epic Pro, which is a device that holds and controls your DSLR while it captures the multiple images needed. The GigaPan Epic Pro is designed to hold a DSLR and lens that weigh up to 10 pounds, but it is important to check whether your camera is supported. You can find out which cameras are supported by which GigaPan models here: http://www.gigapan.com/cms/support/camera-compatibility.

The GigaPan Epic Pro must be mounted on a sturdy tripod and can take a little while to set up. You will need to input the lens information and specify the upper-right and lower-left corners of the panorama. The GigaPan does the rest of the work for you, moving the camera and triggering the shutter for each frame in the multi-row panorama. The GigaPan Epic Pro allows you to take multiple images at each spot on the panorama, and it allows you to shoot bracketed exposures so you can create the ultimate HDR GigaPan panorama.

The only downside to the GigaPan Epic Pro is that it retails for close to $1,000. The good news is that you can try it before you buy it by renting one from Lensprotogo.com or borrowlenses.com.

The second step is to stitch the images together with a specialized software called GigaPan Stitch. With this software you can select the number of rows you used when taking the images so that they can be aligned properly. The real power is that you can tell the software the order in which you took the images (**Figure 35.1**).

GigaPan also allows you to upload your gigapixel panoramas to their website where they can be viewed and printed. For more information, check out gigapan.com.

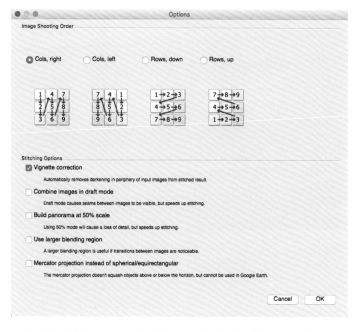

35.1 The Options menu in GigaPan Stitch allows you to specify the layout of the images so that they are stitched together correctly.

35.2 A gigapixel panorama of New York City. Each rectangle of the grid is one image.

4

IMAGE STACKING
AND
FOCUS STACKING

CHAPTER 4

This chapter is all about using stacks of images to create photographs that you could not produce with just a single image. There are a lot of great reasons to take multiple photographs of the same subject. We already covered HDR photography in chapter 3, where each image has a different exposure, but in this chapter we'll talk about using images that have the same exposure. These images can be combined in a variety of ways for a variety of reasons—for example, to reduce noise and remove unwanted objects from your images, as well as for astrophotography. We'll also explore focus stacking for macro and landscape photography. I will tell you right from the start that it's important to use a tripod for all of these techniques.

36. USE IMAGE STACKS IN PHOTOSHOP TO REDUCE NOISE

ONE OF THE best uses for image stacks is to remove the digital noise that appears in images when you use very high ISO settings or leave the shutter open for long periods of time. Digital noise appears as unwanted spots of color, especially in darker areas of constant color and tone. These spots of color are random, so if you shoot the same scene multiple times with the same settings, the noise will appear in different spots in each image. You can see an example of digital noise in **Figure 36.1**, which is the result of using a high ISO, in this case ISO 6400. In **Figure 36.2** you can see the noise in the sky that appeared when the image was blown up to 100%.

Most image-editing programs have noise reduction settings, but these settings usually reduce noise by blurring the image very slightly, which affects the sharpness of the image. With Photoshop's image stacks function, you can combine multiple versions of the same image taken with the same exposure settings, and Photoshop will average all of the pixels and remove any artifact that does not appear in every frame, effectively reducing the appearance of digital noise in the final image.

This technique works best when you have quite a few images to work with, like 8 or 10. Just make sure that your camera is mounted on a tripod and that you photograph the same subject with the same settings every time to ensure that the only thing that varies in the images are the random spots of digital noise. Once you've captured your source images, it's relatively easy to create and process a stack of images in Adobe Photoshop:

1 Open [File > Scripts > Load Files into Stack]. In the Load Layers dialog, select the files you want to use and check the two boxes at the bottom of the window: Attempt to Automatically Align Source Images and Create Smart Object after Loading Layers (**Figure 36.3**). Smart Objects allow you to do nondestructive editing on the layer, which is key when applying a Stack Mode in the next step.

2 Choose [Layer > Smart Objects > Stack Mode], and then select one of the modes from the submenu. There are a few choices and they all do slightly different things with the image stack. The best Stack Mode for removing noise from an image is the Mean Stack Mode.

When you select the Mean Stack Mode, the software looks at all of the nontransparent pixels and averages the values for each. The software does nothing to the pixels that are the same in each image, but wherever noise is present, the pixels are averaged with those that don't have noise in other images and the noise effectively disappears. You can see the difference this makes in the figures below. **Figure 36.4** shows just one exposure, and **Figure 36.5** was created from a stack of 10 images. I used an extremely high ISO for these images to show how well the stacks method actually works when you use it to reduce digital noise. It works just as well for images shot at lower ISOs.

36.1 There is noise in this image of the night sky in downtown San Diego. **ISO 6400; 1/8 sec.; f/8; 30mm**

36.2 When you zoom in on the dark sky, the noise becomes even more visible.

36.3 The Photoshop Load Layers dialog.

36.4 This is just one exposure taken with a very high ISO. You can see that there is a lot of noise in the image. **ISO 204800; 1/100 sec.; f/5.0; 200m**

36.5 This is the same scene shot with the same exposure settings, but this time I used a stack of 10 images and processed them with Photoshop's Mean Stack Mode to reduce the noise in the image. **ISO 204800; 1/100 sec.; f/5.0; 200mm**

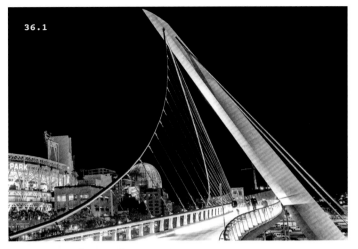

36.1

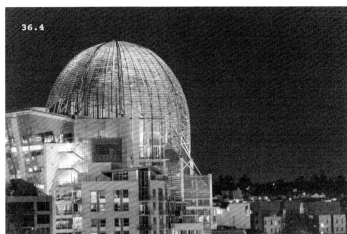

36.4

36.2

36.5

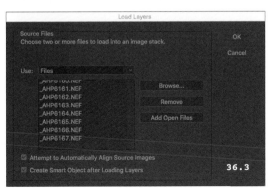

Load Layers

Source Files
Choose two or more files to load into an image stack.

OK

Cancel

Use: Files

_AHP6160.NEF
_AHP6161.NEF
_AHP6162.NEF
_AHP6163.NEF
_AHP6164.NEF
_AHP6165.NEF
_AHP6166.NEF
_AHP6167.NEF

Browse...

Remove

Add Open Files

☑ Attempt to Automatically Align Source Images
☑ Create Smart Object after Loading Layers

36.3

37. USE IMAGE STACKS IN PHOTOSHOP TO REMOVE UNWANTED OBJECTS

ONCE YOU HAVE a set of images loaded as a stack in Photoshop you can apply some of the other Stack Modes. Each one produces a different result, and some of them seem like magic.

My favorite is the Median Stack Mode, especially for scenes in which there are too many people to get a clear shot. Median removes things that do not appear in every image in the stack, such as people and cars. For this to work well, some of the subjects in your image must be static (these are the items that will appear in the final image) and you need to allow enough time between the exposures for the items that you don't want to appear in the final image to move. For example, if you take a series of 20 images over 10 minutes and some of the people in the scene don't move, they will not be removed from the final frame.

Figures 37.1 and **37.2** show a scene I shot at night in downtown San Diego. I left a long enough time gap between each frame for the cars to move, so they were not in the same spot in every frame. In **Figure 37.1** you can see a single frame in which there are cars, while in **Figure 37.2** the cars have vanished.

This trick works really well when you're photographing scenes with a lot of people in them and you want to make the people disappear. It can be really tough to get a clean shot if you're at the beach or a park where there are lots of people moving around. For example, **Figure 37.3** shows what a normal shot of a busy area in Balboa Park looks like. By shooting multiple exposures and creating an image stack, I was able to automatically get rid of the people that I didn't want in the final photograph (**Figure 37.4**). As I said, any object that does not appear in every image is removed, which means that all of the people are gone. The baby stroller on the lower left side never moved while I shot the frames so it appears in the final image.

Because Photoshop's Stacks feature uses a set of images combined into a single Smart Object, you can edit the original images that make up a stack at any time. Choose [Layer > Smart Objects > Edit Contents], or just double-click on a layer thumbnail. After you save the edited Smart Object, the stack is automatically updated with the last rendering applied to the stack of images.

If you want to convert the Smart Object to regular layers to preserve the rendering effect, select [Layer > Smart Objects > Rasterize]. Once you do this, you will not be able to edit the individual layers nor will you be able to apply other Stack Modes. If you make a copy of the Smart Object first, you will have the ability to edit the stack and you will have a copy of the final rendered version.

There are many other Stack Modes besides Mean and Median, and I recommend you play around with them to see what effects they have on the image stack.

37.1 A single frame from the stack showing cars driving down the street.
ISO 3200; 1/8 sec.; f/5; 30mm

37.2 The final frame created from the stack of images with no people or cars in sight.
ISO 3200; 1/8 sec.; f/5; 30mm

37.3 A single frame showing people walking around in Balboa Park.
ISO 800; 1/125 sec.; f/5.6; 50mm

37.4 The final frame created from the stack of images—the scene now looks deserted.
ISO 800; 1/125 sec.; f/5.6; 50mm

38. IMAGE STACKING FOR ASTROPHOTOGRAPHY

IMAGE STACKING IS commonly used in the field of astrophotography, which involves taking photos of the night sky, including stars that are very dim and are not always visible to the naked eye. The main issue when photographing the night sky is that very little light reaches the camera. When you point your camera at the sky and take a single image, you're only able to capture the brightest stars, even if you use a long shutter speed and high ISO (**Figure 38.1**). The goal of stacking multiple images is to increase the signal-to-noise ratio, which gives you more of the information you want with less noise. This will not increase the color or make the overall image brighter, but it will give you more information so you can make those adjustments with image-editing software.

The other issue you can run into when photographing the sky at night is that if you use a longer shutter speed, the stars will look less like stars and more like streaks of light in the sky. This is great if you want to create star trails like those in **Figure 38.2**, but that isn't the type of image we are looking for here.

The solution to this problem is to capture multiple images and use the computational power of the editing software to get the average brightness of the scene. This helps to eliminate the random stuff and makes the details stand out.

Point the camera at an interesting part of the sky and take multiple images, each with a shutter speed of about 10 seconds, a wide open aperture, and an ISO of 800 (**Figure 38.3**). Make sure the focus is set to infinity and the autofocus is turned off.

The number of frames you use for the image stack makes a difference. In short, the more images you use the better. You also need to take a set of images with the same settings with the lens cap covering the lens. These images are called dark frames and the image-editing software uses them to reduce noise through a process called dark-frame subtraction. The stacking software usually requires the same number of dark frames as normal frames, so if you take 50 frames of the sky, you need to take 50 frames with the lens cap on. Once you've taken these images, you can use image-editing software to stack and process them (see lesson 39).

38.1 I used a high ISO to photograph the night sky, which resulted in a noisy image. It's difficult to tell the stars from the digital noise.

38.2 I used a 10-minute exposure to photograph the night sky in the Anzo Borrego Desert, which created star trails in the resulting image.
ISO 400; 10 min.; f/5.6; 20mm

38.3 A single image of the night sky.
ISO 800; 10 sec.; f/4; 70mm

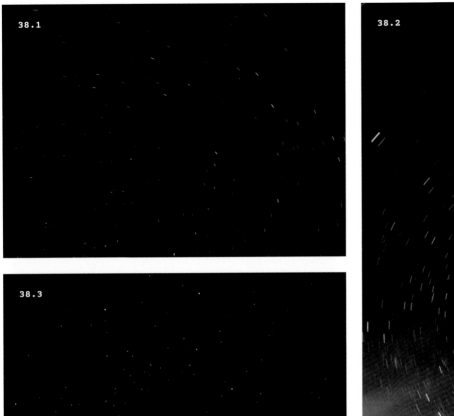

38.1

38.3

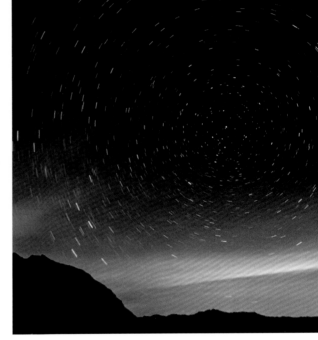

38.2

39. IMAGE STACKING SOFTWARE FOR ASTROPHOTOGRAPHY

THERE ARE MULTIPLE software applications designed to process stacked images for astrophotography. Many of these applications are free or have free trial periods so you can try them out before you buy the one you like best. Two of the most popular applications are DeepSkyStacker and RotAndStack (both for Windows OS), both of which are available for free. These applications combine the images in a stack and generate a final image that is ready to edit in Photoshop or another image-editing program.

When you load an image stack into one of these programs the software performs several adjustments. First, it will align the images so that the stars are in the same place in each image. Because the earth is rotating, the stars are constantly moving, so the software needs to make minor adjustments to each image. It will also perform dark-frame subtraction, which is where the dark frames I mentioned in lesson 38 come into play. While digital noise is mostly random, each camera sensor can have a pattern as to where noise appears. To counteract the noise pattern of your camera, the software subtracts the noise that appears in the dark frames from the normal frames, leaving behind the truly random noise.

Finally, the software package will stack up all of the images and calculate the average of each pixel, resulting in a cleaner image with all of the stars present and the noise greatly reduced. Now you can take the resulting image and edit it in a program such as Photoshop to get the final look you want.

I used a curves adjustment (**Figure 39.1**) to set the black and white points and adjust the color in my final image (**Figure 39.2**).

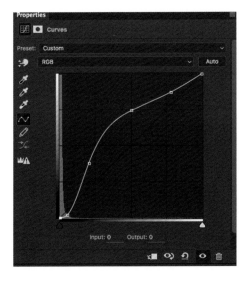

39.1 I used Photoshop Curves to edit my image.

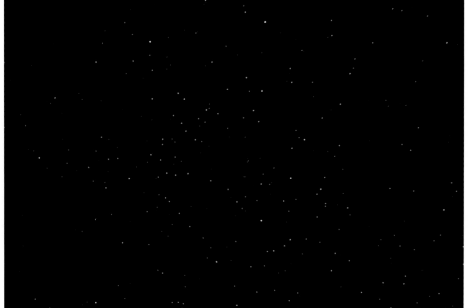

39.2 The final, edited image.

40. FOCUS STACKING

FOCUS STACKING IS when you shoot a series of images of the same subject but with different areas of focus and combine them to create a single image. The final image has a greater depth of field than is possible in a single frame. This technique is most often associated with macro photography (**Figure 40.1**) and can also be used for landscape photography (**Figure 40.2**).

In both of these images the depth of field is greater than that of any of the individual images I used to create them (**Figure 40.3**). For just about every technique I've discussed in this book I have stressed the importance of maintaining the same area of focus from image to image. However, with focus stacking, you will need to adjust the focus for each frame you shoot. You can then use software to combine the in-focus areas and create the final image (see lesson 43).

Focus Where?

As I've already stated, the idea with focus stacking is to take a series of photos with different areas in focus. Your camera will allow you to choose the area in the scene that it will focus on. You do this either by selecting the focus points that overlay the spot in the scene on which you want to focus, or by using manual focus. For example, the Nikon D800 has 51 focus points that cover the center part of the scene, as shown in **Figure 40.4**, and the Canon 7D Mark II has 65 focus points laid out as seen in **Figure 40.5**.

As you can see, both cameras allow you to choose focus points that cover the middle area of the frame. To focus on a spot outside of these focus points, you need to use manual focus. When your camera is set to manual focus, you just turn the focus ring on the lens to change what is in focus.

I have found that focus stacking is a technique in which it is fairly easy to use manual focus. This is because when you're shooting images for a focus stack, you don't need to worry too much about what areas are in focus in an individual frame—you just need to make sure you capture a series of images that, when combined, focus on all of the areas of the scene.

Tip: The live view mode on most cameras will allow you to use a focus area right at the edge of the frame.

40.1 I used a stack of images to create this photograph of a flower. The depth of field is much greater than what I could capture in a single shot.
ISO 800; 1/125 sec.; f/3.5; 105mm

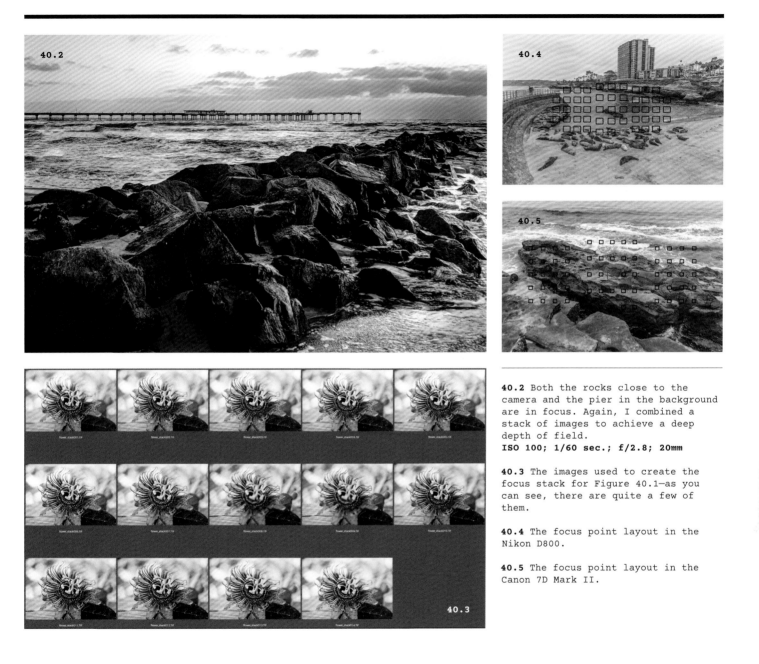

40.2 Both the rocks close to the camera and the pier in the background are in focus. Again, I combined a stack of images to achieve a deep depth of field.
ISO 100; 1/60 sec.; f/2.8; 20mm

40.3 The images used to create the focus stack for Figure 40.1—as you can see, there are quite a few of them.

40.4 The focus point layout in the Nikon D800.

40.5 The focus point layout in the Canon 7D Mark II.

41. FOCUS STACKING FOR MACRO PHOTOGRAPHY

MACRO PHOTOGRAPHY USES specialized lenses that allow for extreme close-up images. These lenses have a very small minimum focusing distance, which also means that they have a very shallow depth of field. Every photographer knows that the aperture plays a major role in determining the depth of field, but the distance between the subject and the lens also plays a role. The closer the lens is to the subject, the shallower the depth of field will be. This doesn't make a huge difference when you're shooting landscapes or portraits, but it has a large effect on macro images. This makes focus stacking perfect for macro photography.

In **Figure 41.1** you can see that due to the shallow depth of field, a lot of the image isn't in focus, even when using a small aperture like f/16.

I used focus stacking to create another image of the same flower in which much more of the flower is in focus (**Figure 41.2**), even though I used a wide aperture of f/4.

To create the second image I took multiple shots of the flower and focused on a slightly different area in each one. Because the depth of field is so shallow in macro photography, I used a lot of images with the focus shifted just slightly in each image (**Figure 41.3**).

To capture a set of macro images for a focus stack, mount your camera on a tripod and switch to manual focus. Start by focusing on the closest part of the subject and take a photo. Then adjust the focus slightly to the next area in the subject and take another photo. Continue in this manner until you've focused on every area in the image.

In **Figures 41.4** and **41.5** you can see that only a very small part of each image is in focus. When these areas are combined (along with all the other images), you get an image in which everything is in focus (**Figure 41.6**)

Here are a few examples of macro images I created by using the focus stacking technique. In the first shot you can see that all of the needles on the cactus are in focus, which would not be possible in a single frame (**Figure 41.7**).

To create **Figure 41.8**, I photographed a couple of figurines outside with a macro lens. I used a very shallow depth of field to keep the background blurry, but I had to use 12 separate images of the figures to get them all in focus. I used the live view mode and moved the focus point around the display, making sure it was only on the figures and never on the background. This gave me the best of both worlds—the background is soft and blurry and the figurines are sharp.

41.1 This macro image of a flower has a shallow depth of field even when using f/16.
ISO 1600; 1/250 sec.; f/16; 105mm

41.2 This macro image of a flower has a very deep depth of field—a look I achieved by stacking images with different focus points.
ISO 100; 1/250 sec.; f/4; 105mm

41.3 The set of images I used to create the macro image in Figure 41.2.

41.4 Only a thin sliver of the image is in focus in this frame.

41.5 Another thin sliver of focus.

41.6 I stacked multiple images to create this photograph in which everything is in focus.
ISO 3200; 1/60 sec.; f/3.5; 105mm

41.7 I used focus stacking to create an image in which all of the needles on the cactus are in focus.
ISO 800; 1/250 sec.; f/5.6; 105mm

41.8 I combined 12 shots of these two little figurines to get an image in which they are both sharp.
ISO400; 1/500 sec.; f/3.2; 105mm

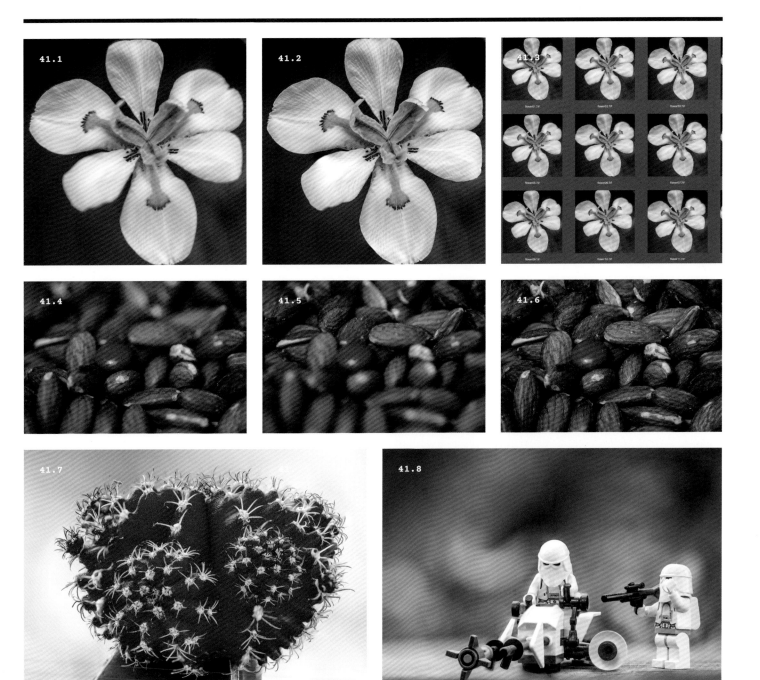

42. FOCUS STACKING FOR LANDSCAPE PHOTOGRAPHY

I LOVE TAKING landscape photos in which the whole scene is in focus. This can be done using a variety of techniques, including using a small aperture, such as f/22, and focusing at the hyperfocal distance. As you've likely guessed, another option is to use multiple images with a variety of focus areas.

Focus stacking is a very useful technique when you are shooting landscapes in low light and have to use a wide aperture. I like to use three images: one with the focus on the foreground, one with the focus on the middle ground, and one with the focus on the background. In **Figure 42.1** you can see an image of a pier in which everything is in focus, from the foreground to the background.

Figures 42.2–42.4 show the individual shots I used to create the final image. I start by focusing on something in the foreground, and then without moving the camera, I shift the focus to the midground, and then finally to the background. I use either autofocus or manual focus depending on where the three areas fall in the frame.

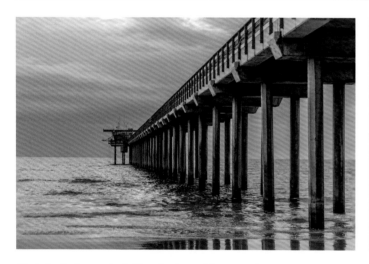

42.1 I photographed the Scripps Pier as the sun was going down so I had to use a wide aperture to let in enough light, which created a shallow depth of field. I combined three images to get the whole pier in focus.
ISO 400; 1/250 sec.; f/2.8; 70mm

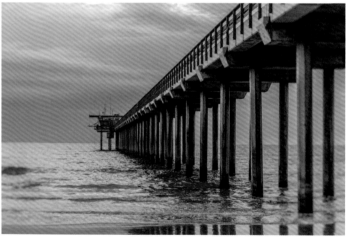

42.2 To capture this image I focused on the area of the pier that was closest to me (the foreground). You can see that the end of the pier is out of focus.
ISO 400; 1/250 sec.; f/2.8; 70mm

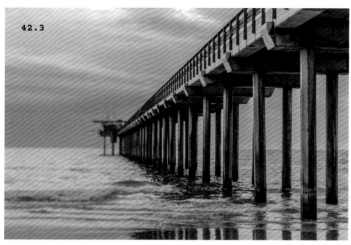

42.3 Next, I moved the focus to the middle part of the pier. The parts closest to me are now blurry and the middle and end of the pier look sharper.
ISO 400; 1/250 sec.; f/2.8; 70mm

42.4 For the final shot I focused on the end of the pier.
ISO 400; 1/250 sec.; f/2.8; 70mm

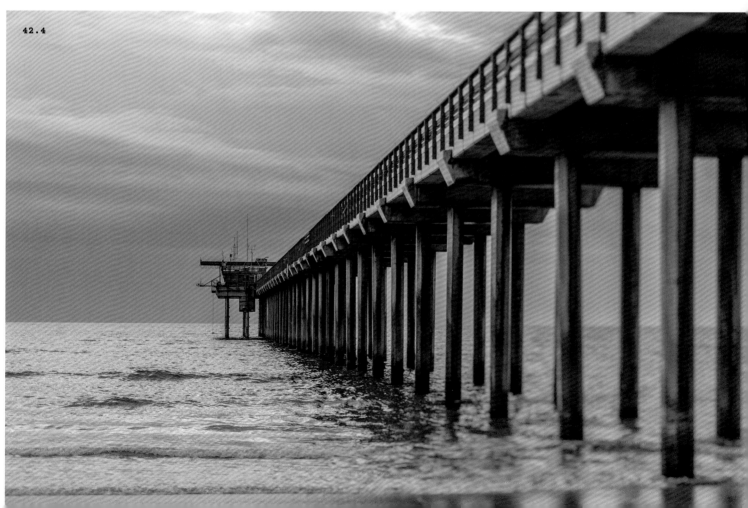

43. FOCUS STACKING IN PHOTOSHOP

ONCE YOU HAVE taken the set of images you will use for the focus stacking set, it's just a matter of getting the software to put them together in the proper way. Back when Adobe released Photoshop CS4 it included a feature called focus blending, which allows you combine multiple images with different areas of focus.

The first step is to load the images into a stack by selecting [File > Scripts > Load Files into Stack]. When the dialog box opens, select the files you want to use and click on Add Open Files (**Figure 43.1**). This creates a file in which each image is a separate layer. To align the layers, shift-click on each layer to select them all, and then select [Edit > Auto-Align Layers]. Select Auto from the Auto-Align Layers menu (**Figure 43.2**). This setting does a fantastic job, especially if the layers are really close already (because you used a tripod, of course).

Now comes the important step—you need to blend the layers together to get the final image. With all of the layers still selected, click [Edit > Auto-Blend Layers] to open the menu shown in **Figure 43.3**. Because Photoshop knows the difference between a stack of images and a panorama, the Stack Images

option should already be selected. I also like to put checks in the boxes next to Seamless Tones and Colors and Content Aware Fill Transparent Areas. Then click OK and Photoshop will create a single image in which everything is in focus.

Figures 43.4–43.6 show some of the steps involved in creating the image shown in **Figure 43.7**.

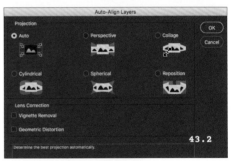

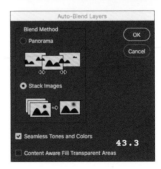

43.1 Photoshop's Load Layers dialog.

43.2 The Auto-Align Layers menu.

43.3 The Auto-Blend Layers menu.

43.4 One image with a single focus area. Compare this to the final image shown in Figure 43.7 to see the difference.

43.5 The set of images I used to create the focus stack.

43.6 Photoshop created layer masks for each image so that they blend together seamlessly. These can be fine-tuned if necessary.

43.7 The final image has a much greater depth of field than could be achieved in a single image.

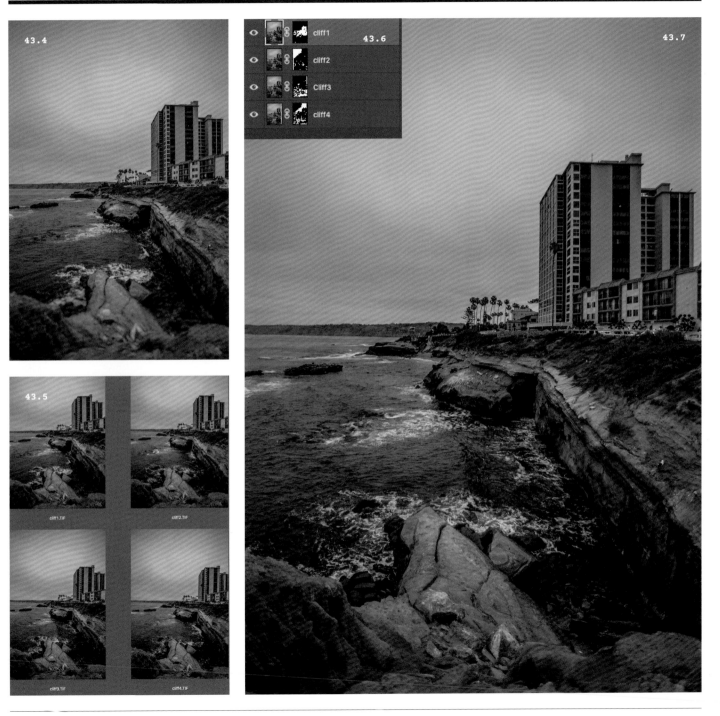

43.4

43.5

cliff1.TIF cliff2.TIF

cliff3.TIF cliff4.TIF

43.6

cliff1

cliff2

Cliff3

cliff4

43.7

5

TIME-LAPSE
PHOTOGRAPHY

CHAPTER 5

Time-lapse photography is a technique whereby you take a series of images of the same subject over time and combine them into a movie that compresses time. When you watch a time-lapse video, it's like watching the world unfold in fast forward. It sounds complicated but it's really quite simple, especially with the built-in time-lapse function on many newer DSLRs. In this chapter I cover both creating a time-lapse in the camera and creating a time-lapse in post-processing with a series of still frames.

44. TIME-LAPSE BASICS

FOR A TIME-LAPSE to work properly and be worth watching, the camera needs to be held stable, there needs to be something interesting going on, you need to be able to take multiple images over time, and the final movie needs to compress the time in a way that keeps the viewers interested. A time-lapse in which nothing seems to be happening or changing can be quite boring. On the flip side, a time-lapse in which there is too much happening or things are changing too quickly can be difficult to watch.

The Basic Gear

To create a time-lapse video, you will need a camera that can take multiple images over time using either a built-in interval timer or an external shutter release that can be set to trigger the shutter at specific intervals. Many cameras have the ability to trigger the shutter at set intervals; check your manual to find out whether your camera can do this. This is different from the ability to create a time-lapse in the camera, which is covered in lesson 47. What you are looking for right now is a feature that allows you to program the camera to take a single still image every few seconds or minutes over a specific period of time.

If your camera does not have this ability, you can use an external timer or intervalometer. This is what I used for years, and I still use one on my cameras that do not have this capability built-in. I have the Nikon MC-36, which has been replaced by the Nikon MC-36A. Both of these models come with the 10 pin connector. I've mentioned this device previously because it also acts as a remote shutter release and allows the shutter to be kept open for longer than the 30-second maximum when you use the Bulb shutter speed. If you are looking for a less expensive version, check out the Pixel Timer (http://www.pixelhk.com) or the Triggertrap software and cables (http://www.triggertrap.com; **Figure 44.1**).

Once you have set the camera to take a series of images, the next step is to mount the camera on a tripod so that it doesn't move during any of the exposures. The setup should be very secure because if the tripod or camera moves even a tiny bit, the entire time-lapse will be affected. Imagine watching a time-lapse movie in which, every once in a while, the scene seems to go out of focus for a split second—this is distracting and can ruin the whole effect. So make sure that the tripod can support your camera and lens and that it is set up properly and on stable ground. I put soft dive weights in my camera bag and hang it from the the center column hook to add weight to the tripod and keep it from moving (**Figure 44.2**).

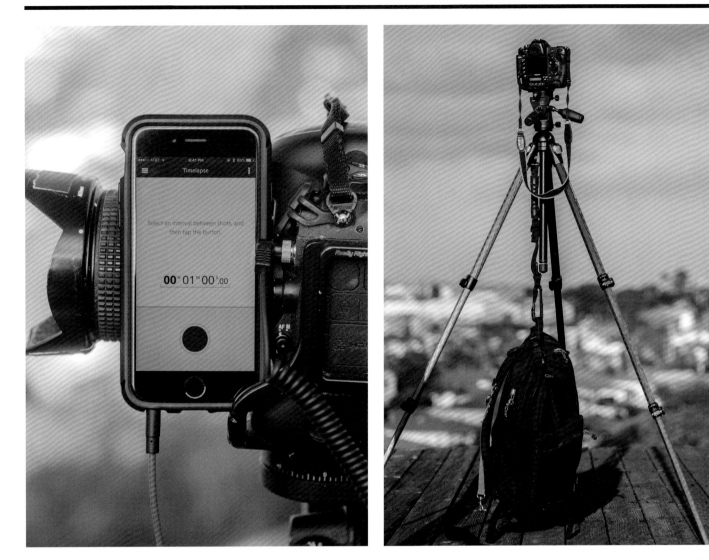

44.1 The Triggertrap software runs on my smartphone, which is connected to the camera via a cable that runs from the phone's headphone jack to the camera's 10 pin connector.

44.2 My camera bag adds weight to the center column, which helps to keep the tripod stable.

Advanced Gear

There are a few pieces of gear that can take your time-lapse photography to the next level. The first item is a slider that allows the camera to move smoothly during the series of exposures. I know I just said the camera needs to stay still during the photo-taking process, but if you set it up properly, you can have the camera move a small distance over the course of the entire time-lapse sequence to add just a little something extra. To do this, you can set a motorized slider to move the camera during the time-lapse creation. It should move for the same amount of time as it takes to shoot the entire series of images.

A second piece of equipment that can make life easier is a neutral density filter. Using a longer shutter speed allows for smoother time-lapse videos. When you shoot in bright light, even if you use the lowest ISO setting and a small aperture, the shutter speed will be too high to give you the smooth look you want. A neutral density filter blocks out the sunlight, which allows you to use longer shutter speeds and wider apertures in bright light and gives you more creative control over your images.

I have a set of two neutral density filters from Nikon (**Figure 44.3**) that can block out four or eight stops of light, which allows me to radically change the shutter speed I'm able to use, especially during the bright daylight. In **Figure 44.4** you can see that the scene is really bright, so the slowest shutter speed I could use was 1/250 second. With the Nikon ND 8 filter, I was able to use a shutter speed as slow as 1/20 second, which is a huge difference (**Figure 44.5**).

If you don't have an ND filter, I suggest that you try doing some regular time-lapse shooting before you run out to buy one since these filters can cost over $100.

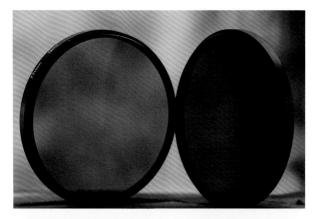

44.3 The Nikon ND4 and ND8 filters allow me to use slower shutter speeds in bright light.

44.4 The bright light in the scene meant that even at the lowest ISO and smallest aperture, the slowest shutter speed I could use was 1/250 second.
ISO 100; 1/250 sec.; f/22; 35mm

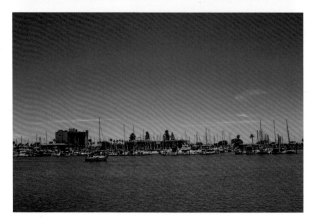

44.5 I shot the same scene with an ND8 filter, which allowed for a much slower shutter speed and a wider aperture, thus giving me more control over the depth of field.
ISO 100; 1/20 sec.; f/16; 35mm

Subject Matter

When choosing the subject matter for a time-lapse video, there are two things to think about: what will move during the length of the shoot and what will stay static? There are some scenes that just scream for a time-lapse recording, like a sunrise or sunset, especially when there are also some great clouds in the sky. When you add a good static subject, like a pier or jetty, then you have something to hold the viewer's attention. One of my favorite places to practice time-lapse is at a dog beach where the dogs can play off-leash, which gives me a lot of moving subjects. This is a great project to start with because you can see the results pretty quickly. In **Figure 44.6** you can see the setup for a time-lapse I shot at sunset on the beach. When shooting on the beach, make sure the tripod doesn't move as the tide changes. **Figure 44.7** is an example of what happens when the water hits the legs of the tripod and the camera moves during the exposure. The blurring in the image is the result of a slight movement of the camera when the water washed some of the sand out from under the tripod leg.

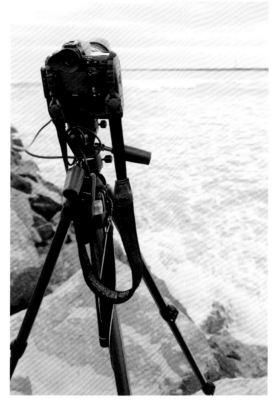

44.6 The setup for shooting time-lapse with the camera secure on the tripod.

44.7 This blurry image is the result of the tripod moving during the exposure.
ISO 100; 10 sec.; f/16; 30mm

45. DO THE MATH

THERE IS SOME math involved in creating time-lapse videos, but don't let that scare you off—it isn't very complicated. The basic concept is to decide how long you want your final time-lapse video to be, and then determine how many individual frames you will need. Then you can work out the amount of time between each frame based on the number of frames and the length of the event you are shooting. Remember, time-lapse photography compresses time so you can watch an event that takes hours in just minutes or even seconds.

The first part of the math problem is to figure out how many frames you need in your movie. This is based on video specifications and the frame rates (frames-per-second, or fps) used to play movie clips—usually 24 or 30 fps (see the Frame Rates sidebar).

The frame rate you choose to use is the basis for the number of frames you need. For example, if you go with 24 fps and you want to create a 30-second movie, then you'll need a total of 720 individual frames (24 × 30 = 720). If you

want to create a 60-second movie, you'll need 1,440 frames.

Once you know how long your movie is going to be and how many frames you need, you can figure out how long the interval between frames should be. The first step is to determine how long the event you are photographing will last. Are you photographing the sunrise over a 30-minute period of time, or is it a much longer event, like a crew breaking down after a concert for four hours? Once you've settled on the length of the event, you need to translate that into seconds. A one-hour event, for example, is 3,600 seconds. So if you want to create a 30-second video at 30 fps to document a four-hour event, you will need to take 900 frames over a period of 14,400 seconds. That means that you need to take a single frame every 16 seconds.

The full equation is:

```
Length of Event in Seconds ÷
Length of Movie in Frames =
Interval Between Frames
```

Sometimes you don't know exactly how long the event you are trying to compress will last. In these cases you should just use your best estimate.

The good news is that there are numerous resources that will do this math for you. My favorite is the T-lapse Calc app for the iPhone, which gives you a very simple, clear, and easy-to-use interface for calculating the time between exposures. You can see the app's data entry screen and the calculated answer in **Figure 45.1**. You can also find free time-lapse photography calculators on the Internet.

Many current DSLRs will allow you to create a time-lapse video in-camera and the camera will do a lot of the math for you. You simply adjust the settings to see the outcome. For example, my Nikon D750 includes a Time-lapse photography menu where I can set the interval and shooting time, and the camera will calculate the length of the movie (**Figure 45.2**). We'll talk about this more in lesson 47.

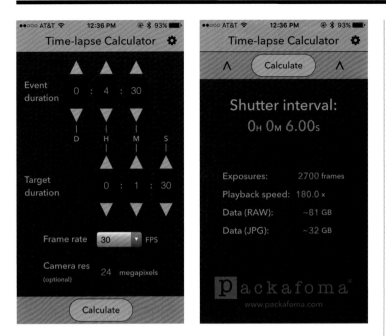

45.1 The T-lapse Calc app gives you the basic info you need to calculate the interval between photos for a time-lapse video.

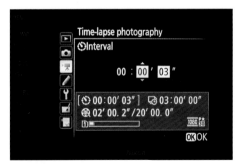

45.2 The Time-lapse photography screen on the Nikon D750 showing the interval, shooting time, and length of the movie.

Frame Rates: 24 or 30 Frames-per-Second?

The standard frame rate for movies shot on film has been 24 frames per second since around 1926 when sound film was introduced. For this reason, many people consider 24 fps to look more like traditional film and the newer, 30 fps standard to look more like digital film. The real reason for the difference in appearance is that you use a different shutter speed for each frame rate, and the shutter speed can affect the amount of motion blur in a movie. The longer the shutter is open, the more motion blur is introduced into each frame. The standard recommendation for recording movies is to use a shutter speed with a denominator that is double the frame rate. So if you're recording at a frame rate of 24 fps, your shutter speed should be 1/50 second (closest to 1/48 second), and when using 30 fps, your shutter speed should be 1/60 second. The images shot at 1/60 second will show less motion blur than the ones shot at 1/50 second. This might not seem like a lot, but it can make the final movie look quite different. This does not really apply when you're creating a time-lapse movie since the movie is not recorded in real time; you're just selecting the frame rate at which the movie will be played back, so you can use either 24 or 30 fps for your output. I use 30 fps for most of my time-lapse movies because I like the way it looks—it's as simple as that.

Share Your Best Time-Lapse!

Once you've captured your best time-lapse video, share it with the *Enthusiast's Guide* community! Follow @EnthusiastsGuides and post your image to Instagram with the hashtag *#EGTimeLapse*. Don't forget that you can also search that same hashtag to view all the posts and be inspired by what others are shooting.

46. CAMERA SETTINGS FOR TIME-LAPSE PHOTOGRAPHY

AS WITH ANY other type of photography, before you shoot images for a time-lapse, you need to determine which exposure, focus, and file type settings to use. You'll need to know what you want to focus on and how to make sure the focus doesn't change during the series of exposures. Selecting a file type is more a matter of choice, but you need to know the differences between the available file types to decide which one you want to use for your time-lapse.

Exposure Settings

Your camera may have a lot of different exposure modes, including modes like Action or Sports, Close-up, and Portrait. All DSLRs have at least four exposure modes: Program (P), Shutter Speed Priority (S), Aperture Priority (A), and Manual (M) (**Figure 46.1**). When you use any of the modes other than Manual, the camera uses the information from the built-in light meter to adjust the exposure settings. In Manual mode, you control how much light is going to be recorded on the sensor by setting the shutter speed, aperture, and ISO. The camera does nothing to change the exposure no matter how light or dark the image is. This is the setting you are going to use for time-lapse photography in just about every case.

When you use Manual mode you need to set the ISO, the aperture, and the shutter speed—but what settings do you use? For a time-lapse you need to think more about the final movie than any of the individual frames. As photographers, we tend to use a shutter speed that freezes the action so that the subjects in the photograph are sharp and in focus. For example, when I photograph surfers I tend to use shutter speeds over 1/1000 second (**Figure 46.2**). But these shutter speeds will cause flickering in a time-lapse.

When shooting video with your camera, you want to use a shutter speed with a denominator that is about double the frame rate. So if you are using a frame rate of 24 fps, the shutter speed should be somewhere around 1/50 second. If you use 30 fps, you'll want a shutter speed of 1/60 second. These settings tend to work best for making the motion in movies look natural, and they work for time-lapse movies as well.

The easiest way to set the exposure for a time-lapse is to set the camera to Shutter Speed Priority and then set the shutter speed to either 1/50 or 1/60 second, depending on your frame rate. Set the ISO to 400, position your camera, and press the shutter release button halfway down to see what aperture the camera selects. If the depth of field is too shallow, increase the ISO; if it is too deep, lower the aperture (make it wider). This is where those neutral density filters come in. If you need to decrease the amount of light coming into the camera, add a neutral density filter. Once you have the

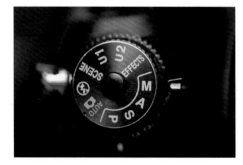

46.1 The exposure mode dial on the Nikon D750. The camera is set to Manual.

46.2 You need to use a fast shutter speed to freeze action for a still shot.
ISO 400; 1/1000 sec.; f/4; 400mm

shutter speed, ISO, and aperture all worked out, change the exposure mode to Manual and enter all three settings.

There are scenes for which it is more difficult to set the exposure, especially if there is a big change in the amount of light during the time-lapse. The best method for adjusting the exposure settings while shooting a time-lapse is to do it manually—simply check the screen on the back of the camera and slowly adjust the exposure as needed. I have found that it works best to adjust the shutter speed a little bit first, and then use the ISO to adjust the exposure further. For example, if you are shooting a time-lapse of a sunset that starts out very bright before the sun starts to set, just do the following:

1 Set the exposure for the current scene.

2 As the sun sets, periodically check the camera after a frame is recorded to see the current exposure.

3 When the scene starts to get too dark, increase the shutter speed by 1/3 stop (from 1/60 second to 1/50 second).

4 As the scene darkens even more, increase the ISO, and continue doing so as the scene gets darker and darker. You want to avoid changing the depth of field or increasing motion blur, which would be more distracting than the increase in the digital noise.

The idea here is to let the scene get darker, but not too dark. This takes a little (ok, a lot) of practice. Some cameras do not allow you to preview the images while creating a time-lapse in-camera. In this case, I would prefer to take a sequence of still images and create the time-lapse with software in post-production. I recommend quickly stopping the time-lapse every so often, checking how it looks, and then starting it back up. Try not to do this too often, but stopping it every once in a while isn't going to make a noticeable difference in the final movie.

Focus Settings

In addition to using the Manual exposure mode, it is also important to use manual focus (**Figure 46.3**). You do not want the camera to change the focus point while shooting a time-lapse. Imagine how weird it would look if the focus kept jumping around the frame while you watched a time-lapse video. If your camera is set to autofocus, it will try to focus right as the shutter release button is pressed down. So if you are taking a series of 900 photos to compress into a time-lapse, the camera will try to focus 900 times and will likely change focus for some of the frames. This will create focus jumps in your final movie.

When I'm setting the focus for a time-lapse, I start with the autofocus turned on. I center the focus point right over the area of the scene that I want to be in focus and I press the shutter button halfway down so that the camera autofocuses. Once the focus has been established, I switch to manual focus.

It is really important for the focus to stay fixed for every exposure in the time-lapse, so try very hard not to touch the camera or lens at any point while the images are being taken.

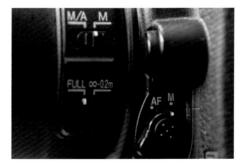

46.3 The AF/M switch on the Nikon D750. Make sure autofocus is turned off before you begin shooting a time-lapse.

As an added precaution, I also make sure the Vibration Reduction or Image Stabilization feature is turned off. This technology is great when you're shooting single frames handheld, but it's terrible when you're shooting a time-lapse because it can cause slight shifts in the focus.

File Type

I prefer to use the RAW file type for most of my photography. A RAW file contains all of the image information straight from the camera's sensor and gives you much more data to use when you're adjusting the look of an image during post-processing. A JPEG file is a compressed file that has basically already been edited in the camera, and while it can be adjusted during post-processing, there is not as much information in the file as there is in a RAW file.

Although there are very few cases in which I prefer to shoot with the JPEG file type, time-lapse is one of them. The main reason for this is that RAW files are very large and take up way too much space in the camera's memory when shooting images for a time-lapse. This doesn't matter if you are creating a time-lapse in-camera because the camera will combine the images into a movie automatically and will not save the individual files.

The benefit of creating a time-lapse from a group of single images in post-processing is that you have access to the individual images and you can use them for other projects. The downside is that you need to use big memory cards to store all of the individual files. And, of course, it takes much longer to create the final time-lapse.

47. CREATING AN
IN-CAMERA TIME-LAPSE

WHEN I FIRST started creating time-lapse movies, there was no option to have the camera create the final file in the camera. When I got my Nikon D4, I was suddenly able to shoot a time-lapse and have the camera create the final movie right then and there. This advance in technology made it possible to shoot a time-lapse and immediately see the results right on the camera.

The first step when shooting an in-camera time-lapse is to set the final output settings. You need to tell the camera the frame rate and frame size to use for output of the movie. As you can see in **Figure 47.1**, there are a lot of choices. You will use the setting you pick here to determine the gap (interval) between each frame.

Once you've adjusted the fps and size settings for the final time-lapse movie, it is time to check out the time-lapse menu. I am using my Nikon D750 as an example here, but the settings on other cameras should be similar; check the user's manual for your specific camera. You can see the Nikon D750 Time-lapse photography menu in **Figure 47.2**.

The menu consists of four settings:

- **Start:** This starts the time-lapse. Do not select this option until you have configured the other settings.
- **Interval:** This is where you set the amount of time between exposures. You can set the time in hours, minutes, or seconds.
- **Shooting time:** This is where you choose the length of time over which the images will be recorded.
- **Exposure smoothing:** This can help reduce flickering between the frames.

That's it. You are now ready record your time-lapse movie. The final output will be a video file, not an image file. The camera does not save the individual image files; instead, it creates the movie one frame at a time.

The advantage of using this method to create a time-lapse is that the movie is made right in the camera with no need for a computer or any post-processing. It also takes up much less space on your memory card. The downside is that you will not have the individual image files used to create the time-lapse.

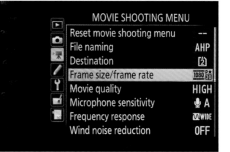
47.1 Movie Shooting menu on the Nikon D750.

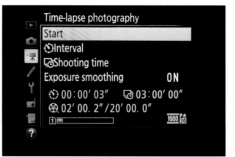
47.2 The Nikon D750 Time-lapse photography menu.

48. CREATING A TIME-LAPSE
FROM STILL IMAGES IN PHOTOSHOP

IF YOU DECIDE to create a time-lapse movie yourself—either because your camera can't do it automatically or because you want to have all the individual image files for some other use—you can do it pretty easily in Photoshop.

To make life easier, I suggest putting all the files that you will use to create the time-lapse into a unique folder. This way you can easily navigate to the folder when creating the time-lapse in Photoshop and you don't have to try and remember where the time-lapse starts and where it stops.

Follow these steps to create a time-lapse in Photoshop:

1 Open Photoshop and choose [File > Open].
2 Navigate to the folder containing the time-lapse images and click on the first image.
3 Check the Image Sequence box (**Figure 48.1**).
4 Click Open and a pop-up menu will ask you to input a frame rate for the movie.
5 Enter the frame rate you used to calculate the number of images you shot (**Figure 48.2**).
6 Choose [File > Export > Render to Video]. You will be presented with four output selections (**Figure 48.3**):
- **Location:** This is where you enter the new filename and the location of the movie.
- **File Options:** This is where you can set the size and type of the movie.
- **Range:** This lets you choose the first and last frames of the sequence.

- **Render Options:** This lets you adjust the Alpha Channel, 3D Quality, and High Quality Threshold. I have never adjusted any of these settings.
7 Click on Render and be prepared to wait as Photoshop creates the time-lapse movie. The longer the movie is and the more frames there are, the longer it takes to process.

48.1 When opening a set of images to create a time-lapse, it's important to make sure the Image Sequence checkbox is checked.

48.2 Make sure the frame rate you enter here is the same as the one you used to calculate how many images to take.

48.3 The final step is to export the images as a movie using the [Export > Render to Video] options.

49. CREATING A TIME-LAPSE FROM STILL IMAGES IN PANOLAPSE

THERE ARE OPTIONS other than Photoshop for combining still images into a time-lapse movie. Some of these software programs actually give you a lot more control and many more functions than the built-in functions in Photoshop. One of my favorites is called Panolapse. It allows you to not only create a time-lapse movie, but also to add motion to your movies. There are features that allow you to zoom in, deflicker, and use auto-exposure settings. You can also create a time-lapse from images that were shot with a fisheye lens, or simulate a fisheye look even if the images were shot with a standard lens. The software can also be used to create animated 360-degree panoramas.

The Panolapse software is available at www.panolapse360.com and is available for both Windows and Mac OSX. A full license costs less than $100, and you can download a free trial version before buying a license.

Using Panolapse is pretty simple, but it will take some time to get the results you want. The simple workflow is to shoot your photos, import the JPEGs into the software, set the initial lens settings (**Figure 49.1**), add motion and deflicker if desired, and then export the final file as a movie.

To get started, open the Panolapse application and click on Import Photos to Panolapse at the top left of the screen. The Lens setting menu will automatically open and you can

enter the focal length in mm, the crop factor of the camera, and the lens type. After all the images are loaded into the main window (**Figure 49.2**), you can add motion to the movie by clicking on a single frame and selecting the Key checkbox, then using one of the following commands: left-click to pan/tilt, right-click (or hold CTRL or Command key) to roll, and use your mouse wheel or trackpad to zoom. This establishes how the start of the time-lapse will look.

Move the Animation Slider to the end of the movie, click on the Key checkbox, and adjust the settings for the last frame. Then click Export frames to open the Export menu (**Figure 49.3**).

The Deflicker control in the Export menu allows you to smooth the scene brightness by adjusting the brightness of each frame to a moving average, which is defined by the size of the Rolling window. A value between 8 and 25 is a good general setting according to the software creators.

When you click on Render all, Panolapse will create your time-lapse movie with motion.

The Panolapse software also has a feature that you can use to even out the exposures of the images using the EXIF data of each image. This is particularly useful if you changed your exposure settings while shooting images for the time-lapse, as discussed in lesson 46. Panolapse allows you to easily blend one frame into the next using the RAWBlend module (**Figure 49.4**).

All you have to do is adjust the settings for the first and last frames of the time-lapse and the software will deal with the rest. The RAWBlend module reads the metadata for key images and then works out the settings needed to make the adjustments smooth. It will smooth out the exposure, white balance, and contrast over multiple frames quickly and easily. RAWBlend can work with both RAW and JPEG files.

In **Figure 49.4**, you can see the RAWBlend workspace and the automatic adjustments it has applied to the individual images. All I did was edit the first and last frames of the sequence in Lightroom, and then I chose [Metadata > Save Metadata to File] before importing the images into RAWBlend. Once I have loaded the images into RAWBlend and selected the Key frames by checking the boxes in the Key column next to the first and last frames, I can click on Save All Metadata and open the images by importing them into the Panolapse software, as discussed earlier.

Creating time-lapse movies can be really fun. I make them often for the concert venue where I work. We've created time-lapse movies of the improvements made to the venue and of certain stage breakdowns to use as marketing tools. It might seem quite boring to sit at a camera while it takes hundreds or even thousands of images, but the final product is worth it.

Lens settings

Sunset_TL[1-292].jpg (292 frames)
Please enter the lens settings of the image sequence.

Focal Length `20` mm

Crop Factor `1` x

Lens type Normal (rectilinear) ▾

Output lens type Normal (rectilinear) ▾

[Cancel] [Done]

49.1 When you import a series of images into Panolapse, you get to choose the lens settings (focal length, crop factor, lens type, and output lens type) for the images.

49.2 The Panolapse work window shows the movie in the main frame and the individual image files below.

Export...

Export settings

Output Width `1280` Aspect ratio: 1.778
Output Height `720` Set size: [Optimal max] [1080 HD]

☑ Deflicker [Select sample area (entire image)] Rolling window `12` ↕ [Reset to Default]

File Format [JPG images (highest) ▾] FPS `23.976` ↕

Output Folder [Browse] Desktop/ [Queue for render]

[Render Queue] [Output Log]

| Output folder | Name | Date | # | Size | Type | fps | Deflicker | Remove task |

[Close] [Render all]

49.3 The Export menu allows you to adjust the output settings and set the Deflicker control to smooth the scene brightness.

RAWBlend

RAWBlend allows you to interpolate photo settings (such as exposure, contrast, white balance) across RAW/JPG images.
For help, please visit http://www.panolapse360.com/rawblend/

[Import image sequence...] [Reload All Metadata]

Files: /Users/Shotlivephoto/Desktop/TimeLapse1 (292 frames)

Key	Filename	Settings	Temp	Tint	Exposure	Contrast	Highlig...	Shadows	Whites	Blacks	Vibrance	Saturati...	ToneCur...	ToneCur...	ToneCur...	ToneCurve4
☑	Sunset_TL0001.JPG	f/6.3, 1/60s, ISO 640	0	0	0	0	0	0	0	0	0	0	0	0	0	0
☐	Sunset_TL0002.JPG	f/6.3, 1/60s, ISO 640	0	0	0	0	0	0	0	0	0	0	0	0	0	0
☐	Sunset_TL0003.JPG	f/6.3, 1/60s, ISO 640	0	0	0	0	-1	0	0	0	0	0	0	0	0	0
☐	Sunset_TL0004.JPG	f/6.3, 1/60s, ISO 640	0	0	0	1	-1	1	0	0	1	0	0	0	0	0
☐	Sunset_TL0005.JPG	f/6.3, 1/60s, ISO 640	0	0	0	1	-2	1	0	0	1	0	0	0	0	0
☐	Sunset_TL0006.JPG	f/6.3, 1/60s, ISO 640	0	0	0	1	-2	2	0	0	1	0	0	0	0	0
☐	Sunset_TL0007.JPG	f/6.3, 1/60s, ISO 640	0	0	0	1	-3	2	0	0	1	0	0	0	0	0
☐	Sunset_TL0008.JPG	f/6.3, 1/60s, ISO 640	0	0	0	1	-3	2	0	0	2	0	0	0	0	0
☐	Sunset_TL0009.JPG	f/6.3, 1/60s, ISO 640	0	0	0	1	-4	3	0	0	2	0	0	0	0	0
☐	Sunset_TL0010.JPG	f/6.3, 1/60s, ISO 640	0	0	0	2	-4	3	0	0	2	0	0	0	0	0
☐	Sunset_TL0011.JPG	f/6.3, 1/60s, ISO 640	0	0	0	2	-4	4	0	0	2	0	0	0	0	0
☐	Sunset_TL0012.JPG	f/6.3, 1/60s, ISO 640	0	0	0	2	-5	4	0	0	3	0	0	0	0	0
☐	Sunset_TL0013.JPG	f/6.3, 1/60s, ISO 640	0	0	0.01	2	-5	4	0	0	3	0	0	0	0	0
☐	Sunset_TL0014.JPG	f/6.3, 1/60s, ISO 640	0	0	0.01	2	-6	5	0	0	3	0	0	0	0	0
☐	Sunset_TL0015.JPG	f/6.3, 1/60s, ISO 640	0	0	0.01	3	-6	5	0	0	3	0	0	0	0	0
☐	Sunset_TL0016.JPG	f/6.3, 1/60s, ISO 640	0	0	0.01	3	-7	5	0	0	4	0	0	0	0	0
☐	Sunset_TL0017.JPG	f/6.3, 1/60s, ISO 640	0	0	0.01	3	-7	6	0	0	4	0	0	0	0	0
☐	Sunset_TL0018.JPG	f/6.3, 1/60s, ISO 640	0	0	0.01	3	-8	6	0	0	4	0	0	0	0	0
☐	Sunset_TL0019.JPG	f/6.3, 1/60s, ISO 640	0	0	0.01	3	-8	7	0	0	4	0	0	0	0	0
☐	Sunset_TL0020.JPG	f/6.3, 1/60s, ISO 640	0	0	0	4	-9	7	0	0	5	0	0	0	0	0
☐	Sunset_TL0021.JPG	f/6.3, 1/60s, ISO 640	0	0	0.01	4	-9	7	0	0	5	0	0	0	0	0
☐	Sunset_TL0022.JPG	f/6.3, 1/60s, ISO 640	0	0	0.02	4	-10	8	0	0	5	0	0	0	0	0
☐	Sunset_TL0023.JPG	f/6.3, 1/60s, ISO 640	0	0	0.02	4	-10	8	0	0	6	0	0	0	0	0
☐	Sunset_TL0024.JPG	f/6.3, 1/60s, ISO 640	0	0	0.02	4	-11	8	0	0	6	0	0	0	0	0
☐	Sunset_TL0025.JPG	f/6.3, 1/60s, ISO 640	0	0	0.02	5	-11	9	0	0	6	0	0	0	0	0
☐	Sunset_TL0026.JPG	f/6.3, 1/60s, ISO 640	0	0	0.02	5	-12	9	0	0	6	0	0	0	0	0
☐	Sunset_TL0027.JPG	f/6.3, 1/60s, ISO 640	0	0	0.02	5	-12	10	0	0	7	0	0	0	0	0
☐	Sunset_TL0028.JPG	f/6.3, 1/60s, ISO 640	0	0	0.03	5	-13	10	0	0	7	0	0	0	0	0
☐	Sunset_TL0029.JPG	f/6.3, 1/60s, ISO 640	0	0	0.03	6	-13	10	0	0	7	0	0	0	0	0
☐	Sunset_TL0030.JPG	f/6.3, 1/60s, ISO 640	0	0	0.03	6	-14	11	0	0	7	0	0	0	0	0
☐	Sunset_TL0031.JPG	f/6.3, 1/60s, ISO 640	0	0	0.03	6	-14	11	0	0	8	0	0	0	0	0
☐	Sunset_TL0032.JPG	f/6.3, 1/60s, ISO 640	0	0	0.03	6	-15	12	0	0	8	0	0	0	0	0
☐	Sunset_TL0033.JPG	f/6.3, 1/60s, ISO 640	0	0	0.04	6	-15	12	0	0	8	0	0	0	0	0

☑ Autoexposure Select: all none ☑ Temp ☑ Tint ☑ Exp ☑ Con ☑ Hi ☑ Shad ☑ White ☑ Black ☑ Vib ☑ Sat ☑ TCurve

Interpolation Mode: [Smooth (Cubic) ▾] [Save All Metadata]

49.4 The RAWBlend workspace with adjustments shown in the Exposure, Contrast, Highlight, Shadows, and Vibrance columns.

INDEX